HOW TO WIN A ROMAN CHARIOT RACE

D1510396

022 546 42 7

HOW TO WIN A ROMAN CHARIOT RACE

LIVES, LEGENDS AND TREASURES FROM THE ANCIENT WORLD

JANE HOOD

ICON

This edition published in the UK in 2015 by Icon Books Ltd.

Previously published in the UK in 2014 by
Icon Books Ltd, Omnibus Business Centre,
39–41 North Road, London N7 9DP
email: info@iconbooks.com
www.iconbooks.com

Sold in the UK, Europe and Asia
by Faber & Faber Ltd, Bloomsbury House,
74–77 Great Russell Street,
London WC1B 3DA or their agents

Distributed in the UK, Europe and Asia
by TBS Ltd, TBS Distribution Centre, Colchester Road,
Frating Green, Colchester CO7 7DW

Distributed in Australia and New Zealand
by Allen & Unwin Pty Ltd,
PO Box 8500, 83 Alexander Street,
Crows Nest, NSW 2065

Distributed in South Africa
by Jonathan Ball, Office B4,
The District, 41 Sir Lowry Road,
Woodstock 7925

Distributed in Canada by Publishers Group Canada,
76 Stafford Street, Unit 300
Toronto, Ontario M6J 2S1

ISBN: 978-1848319-946-2

Text copyright © 2014, 2015 Jane Hood

The author has asserted her moral rights.

No part of this book may be reproduced in any form, or by any
means, without prior permission in writing from the publisher.

Typeset in Centaur by Marie Doherty

Printed and bound in the UK by
Clays Ltd, St Ives plc

For Bryn, Carys and Elen who are everything.

ABOUT THE AUTHOR

Jane Hood has been a lecturer in Classical Languages and Literature, and in Philosophy, ending up as a fellow in Ancient Philosophy at the University of Oxford, specialising in Aristotle and Ancient Medicine. She has held research fellowships in Philosophy in Paris and in Ancient Medicine with the Wellcome Institute in London. She is also a qualified teacher who has taught people from the ages of four to 72. She likes nothing more than a few peaceful moments by the sea on the Gower in South Wales.

CONTENTS

INTRODUCTION

This is a miscellany. There is no other justification for its content than that it includes the things that I find funny, terrible, entertaining or important. If there is a theme running through this book, it follows the point made by the historian Thucydides when examining the origins of the Peloponnesian War, the war that tore ancient Greece apart. He said that human nature, being what it is, will do the same and similar things again. That is why his history was said by him to be a *ktema es aei* – a possession for always – because we always make the same mistakes.

When we look at the ancient world, it is as though we are looking in an old mirror: the sort that is speckled with black as the sheen has worn off. The sort where the old glass has started to slip and ever so slightly distort the image that we see. We are looking at ourselves by looking at the ancient world: it is both familiar and unfamiliar at the same time. It is our culture and it is not.

This is a book that picks out the best and the worst of another world, and there are two aspects to the topics chosen. The first is that of the distorted mirror. The second is that of a continuum. There is a story that links us to the past. Each day that we trace it back leads us closer to a world that is no more. It is the reverse of the conundrum of the watchmaker's watch or Theseus' ship: you replace each part over time, but is it still the same watch? Is it still the same ship? Each day takes us further from that past, but

is it still our past? Of course, it has to be; it is just a little more alien with each day.

The Greeks, the Romans, the Egyptians and the people of the Near East, even 2,000 or more years ago, are our brothers and sisters who taught us how to be civilised. If we look at them straight on in the mirror, we can recognise the same problems, the same love affairs, the same wars and the same issues over property. But we also need to assimilate the distance that keeps us apart in order to learn the lessons of history, poetry and philosophy that remain constant.

We love as intensely as they did because we are, essentially, the same animals: the time that has passed is too short for us to be genetically significantly different. But the world operates in a dramatically different way now, and the pressures we face are, most of the time, not comparable. How many ancient Greeks were there complaining about overtime in the office? Or about mortgage rates? Near Eastern children's toys were stuck together with the bitumen that bubbled naturally to the surface. Would you believe its first use would be as glue today, if oil started flowing in a park in Birmingham?

On the other hand, we have precisely the same struggles. Women (because the buck always stops there) cared very much about effective methods of contraception. Men cared about a night out and the flute girls. Has anything really changed?

There are also long-standing problems. The Greeks brought to us mathematical systems that are the basis of our understanding of the universe. Unfortunately, there

is still not one complete version that works in all circumstances. There are atoms, the uncuttable fundamentals of the universe, devised by Democritus and Leucippus, but no one knows yet whether they are matter or waves. What does it mean to be 'good'? Who *really* is my friend?

A lot of muttering tweed-wearing old schoolteachers gave Classics a very bad name because, I think, they made the subject incredibly dull, and that notion lives on today. No one, apart from a hardened military historian, really wants to read about precisely when Caesar dug a ditch or built a rampart.

I hope this book will make you think again about it all. Really, there was a world of lust, learning, fighting, food, joy and death that the ancients took part in. They really were a lot like us. They just didn't have an iPhone. But they *did* have a computer ...

WHAT IT WAS LIKE ...

This section is rather a rag bag from the past. But then a lot of history is. It looks at some of the more outré aspects of the past and is intended to give a burst of flavour of the classical world. Like them or hate them: just enjoy.

Chariot racing and Roman hooligans

Roman chariot racing was a bit like a cross between top-flight football and Formula 1 racing. It was prestigious, it was fast, it could easily be deadly and it was exceptionally partisan.

Throughout the Roman period, there were four main chariot racing teams: the Reds and the Whites (the two original superstar teams) and the Blues and the Greens (who were the later superstars), which were associated with different areas of Rome. The Emperor Domitian (AD 51–96) added another two teams, but they were dropped on his death (as was almost everything to do with him, he was so hated). The teams were named after the colours they wore, so they could be spotted easily by their supporters. Rather like a team strip.

Chariot racing was also linked to legend. It is said that Romulus used racing just after he founded Rome to distract the Sabine men, the local tribe. They were so absorbed in

the races, they did not notice that Romulus and his men had carried off the Sabine women and that they became the first Roman wives.

Racing took place on a long oval track, called a *circus*; usually it had ascending tiers of seats, the poor at the bottom in the sun, and the shaded rich above under a sun screen. The most famous is the *circus maximus* in Rome, which had a direct connection to the royal palace, so the emperor could walk there unmolested and escape, if necessary. The circus was more open at one end because there were a series of sprung traps, or gates, rather like the ones in modern horse racing, which were used to make sure each chariot (whether pulled by two, four or more horses) had a fair start when the emperor dropped the cloth marking the beginning of the race.

In the middle of the oblong racing track was a space called the *spina*. It separated the two sides of the track and became filled with ornate stone obelisks and columns. One of the tactics encouraged in a race was to try to get your opponents to smash into the *spina*. This could clearly be deadly, as the Romans had changed technique from the Greeks: the Greeks had held the reins in their hands, but the Romans tied them round their waists. When the Greeks crashed a chariot, they could let go, and so had some chance of surviving. The Romans, however, were often dragged along behind a chariot if it were still moving, until they died. To try to avoid this, they each carried a knife to cut the reins, but that assumed that you were in any state to do so. There were other pretty brutal techniques: you could

have several chariots from your team in a race, and that meant you could gang up on the other teams and try to get them smashed into the *spina*.

The *metae* were at the far ends of the *spinae*: they were the large, gilded turning posts that demanded Formula 1 style cornering in order to get ahead. They were the place for horrific crashes. The Romans called the smashed chariots *naufragiae*: shipwrecks.

The races were, with this level of danger, necessarily short, seven or five laps only. That meant that there could be, on average, 24 races a day, and races could be held on 66 days of the year. Why so many race days? Well, one answer that almost always fits with the Romans is money. The more races you have, the more betting there can be. Another answer is that the poor had nothing to do by the time of the Empire. Beforehand, under the Republic, there had been much in terms of trade and the military for them to be absorbed into. By the time the Empire was in full swing, everything had become more professional, so the best you could do was to entertain them and so keep them quiet: *panem et circenses* (bread and circuses).

The charioteers themselves, the *aurigae*, could be hero-worshipped just like modern footballers or racing drivers. Interestingly, most were slaves, hoping to win enough prize money to buy their freedom. Of course, you had to live long enough to reach stardom, which was rare, though some cases have been documented. One was called *Scorpus*. He is said to have won over 2,000 races before a fatal crash when he was 27 years old. The most notable of all, however, was

the illiterate Romano-Hispanic Gaius Appuleius Diocles. He won 1,462 races, over a quarter of all races he took part in. He is said to have retired at the very old age of 42 (in charioteer terms), with winnings totalling 35,863,120 Roman sesterces. That would have been enough money to provide grain for the entire city of Rome for a year. It has been calculated to be equivalent to approximately US$15 billion now. As Professor Peter Struck has rightly pointed out, that would make him the best-paid sportsman of all time.

Modern football is known for the often highly partisan nature of fans devoted to their teams. Likewise, extreme violence could erupt due to devotion to chariot teams, and the way the fans behaved has much in common with modern hooliganism.

Serious tensions between the Reds and the Whites were already established by AD 77, together with the extreme emotions that can go along with such rivalry. At that time, a funeral was held for a Red charioteer and one of his fans threw himself on his funeral pyre. There were clashes between different groups of supporters during the races and also at designated, pre-arranged places away from the stadium.

Nowadays sometimes footballers on the team you don't favour have coins and small missiles thrown at them on the pitch. The Romans had a no-holds-barred take on spectator involvement, as there is evidence that the fans would throw lead curse charms that were studded with nails at a charioteer who was interfering with the progress of their favoured team.

The *circus* was the only time that the emperor showed himself to a mass gathering of the populace. This, clearly, led to political undertones in the dealings that the audience had with the emperor and also the chariot teams. It is recorded that the audience even used to shout out to the emperor about policies they didn't like to try to dissuade him from them. Why would he care what the masses thought? Well, there could be trouble.

Chariot-focused violence reached its height in the Byzantine period in Constantinople (modern Istanbul), then the capital city of the Empire, in AD 532. This was because violent factions of fans had grown powerful and politically-focused in Byzantium under the Emperor Justinian I. This included supporting those who wanted either to oust or support the present emperor as well as taking sides on theological issues that were a hot topic. It had reached the point that the Imperial guards could not maintain order during the races without the help of the supporting factions.

But it all went horribly wrong. As a result of violent hooliganism after a chariot race, in AD 531 several fans of the Blues (Justinian's own favoured team) and the Greens were arrested for murder and were due to be hanged. However, in 532, two escaped and sought sanctuary in a church.

Justinian was trying to broker peace with the Persians with whom he was in conflict at the time, so the last thing he needed was clear weakness at home. To try to calm it all down, he said there would be an extra chariot

race and that the two could be imprisoned rather than killed. An angry crowd demanded that they were completely set free.

Unfortunately, geography was against Justinian as the Byzantine racetrack called the *Hippodrome* was next to the palace area. The cheers in the stadium suddenly changed from supporting teams to '*Nika*', 'Win!' The mob grew angrier and angrier and finally attacked the palace and held it under siege for five days. The fires the mob started burnt down most of the city.

Justinian wanted to call it a day and flee, especially as some of the senators decided it was the perfect time to overthrow him and so stop the new taxes he proposed. His wife, Theodora, would have none of it, saying that royalty was the best burial shroud and she would never be alive and not called empress. So he stayed.

In the end, playing off the chariot-racing factions saved Justinian. The story goes that he sent a favourite eunuch into the Hippodrome, which was now the seat of rebellion, with a big bag of gold. He went to Justinian's team, the Blues, and, basically, bought them off, while pointing out that the person they were looking to put in the emperor's place supported their rivals, the Greens. While in the middle of crowning the new emperor, the Blues stormed out and the guards rushed in, killing the remaining rebels. About 30,000 are said to have died.

Anyone who says that devotion to sporting teams cannot inspire such deep devotion and deep hatred, clearly has not thought about the *Nika riots*.

Cosmetics, skincare and
how to be beautiful the ancient way

For everyone out there slightly addicted to the three-step routine, think about how the ancients had to cope. Good make-up, hairstyling and skincare were the preserve of the wealthy: the ingredients were expensive, you needed to have time to spend on yourself and being beautiful had to be important (rather than your focus being merely on staying alive).

Another thing you might be addicted to is tanning – in the sun, on holiday or in a salon. If so, you are completely out of line with the ancients. They thought pale, fair skin was the height of beauty, along with blonde hair and blue eyes, which were very rare in the Mediterranean. Rather than cooking yourself on the Costas, pale skin meant that you were rich and could spend the heat of the day cloistered inside. You weren't tanned because you weren't toiling outside with poor people and slaves. You even had special slaves, *cosmetae*, who put make-up on for you, often in special rooms that men were not meant to enter.

To get even paler, women used to paint their faces with white lead. This was no more a good idea for skin than was the use of lead pipes in Roman water systems, but even though the Romans might have realised that lead was highly toxic and almost certainly lowered their life expectancy, they still used it. They also used chalk as a face powder: it would wear off very quickly, but at least didn't kill you.

Skincare was an important part of routine, particularly

for upper-class Roman women. Honey was used as a moisturiser and olive oil was used to make skin shine. The Romans are reported not to have liked wrinkles, freckles or blemishes of any kind, and facemasks were common. For instance, freckles were treated with the ashes of snails. Facemasks were made of more or less anything you could think of, and, just as today, there was a spectrum between extravagant claims and more researched, even medical, approaches to skincare. Ingredients included eggs, juice, seeds, placenta, excrement, crocodile dung and animal urine. You can imagine that there were many complaints about the smell.

Some other things don't change. There was designer make-up. This often came from Egypt, Gaul (roughly, modern France) and Germany. They also led to the fakes that often smelt vile because of their cheap ingredients. Just like a knock-off Chanel handbag that you can buy in a dodgy market, there were copies of the best Roman make-up that never looked quite right either.

The most garish cosmetics were used by prostitutes to mark themselves out, although upper-class Romans did use colours too (as long as they stayed pale). *Lenocinium* could mean 'make-up' or 'prostitute'. Lipstick was made as a paste often using red clays or iron oxide. Blusher could be made from chalk, rose petals, red lead and crocodile dung. Charcoal and olive oil were used as an eye shadow. Eyebrows were also darkened. Kohl was used a lot. You had to be careful, though: Pliny the Elder (AD 23–79, who died when Mount Vesuvius erupted and buried the city of

Pompeii) claimed that a woman's eyelashes fell out if she had too much sex. So you had to hang onto them to prove that you were chaste!

Freewomen in Greece had long hair, which they wore up with pins, combs and even scarves. Archaeologists have found hats with holes in them, which would allow women to keep their skin pale but expose their hair to the sun. Women also put vinegar on their hair so that it would be lighter (just like we used to use lemon juice at school). Hair was conditioned with olive oil. Only slave women had short hair.

As for any other bodily hair, the Romans didn't like it, and there were pretty much the same options as today: you could pluck it out, shave it off or do the equivalent of waxing with a paste made from resin. One way of dealing with it that, thankfully, we don't still employ is scraping it off with a pumice stone ... Ouch.

Perfume was also an important part of ancient beauty. If you think how vile an ancient city could have smelt, you can see how important it was to smell sweet, especially as that was linked to being healthy. There was a large and important perfume market that also included making pretty perfume bottles, often out of beautifully blown glass.

Depending on which women's magazines you read (if any, of course), you will appreciate that men have always had an uneasy relationship with women's cosmetics. Some love it when a woman is made up to the nines, some claim they like the purely natural look. The same story can be seen in the ancient world: men found cosmetics, and the

changes to the appearance that they can make, very difficult to deal with. The Christians were, generally, completely against them, as you should have the pure appearance that God gave you. Some accused women who wore make-up of being witches who aimed to deceive. The Roman satirist Juvenal said that a woman buys scents and lotions with the intention of adultery. The Stoic Seneca (p. 191) thought that the use of cosmetics was in line with the decline in Roman morality. The poet Ovid is the only one who writes in approval of cosmetics, but he did write the *ars amatoria*, *The Art of Love* (an early version of *The Joy of Sex*).

Men used treatments too, though it was generally frowned upon. It was a difficult game for them: if they did nothing to look after their appearance, they could be seen as rough and uncultured. Freedmen (ex-slaves) and criminals wore leather patches to cover up where they had been branded. But if men cared too much, for instance carrying a mirror around, then they were seen as effeminate. One of the chief offenders was the Emperor Elagabalus (p. 38). His cross-dressing ways eventually led to him being beheaded by his own imperial guard.

Londinium

London: the capital of Britain and one of the chief financial and cultural centres of the world. It started under its present name in the 1st century AD, not as the capital of Roman Britain – that was Colchester – covering only an

area about the size of Hyde Park (about 1.4km^2). This is when you could have made a killing in property …

From the start, Londinium was about trade and finance. The fiscally aware Emperor Claudius would never have crossed the troublesome Channel in AD 43 if he had not thought there was money to be made. It seems that London began somewhere near the present London Bridge. The remains of a pier have been found here, suggesting that this was the point at which the River Thames was deep enough for ships to pass, but narrow enough for a bridge to be built. There is no evidence of a military base near the pier. That makes it the product of venture capitalism. The archaeology of the cosmopolitan goods found backs this up: if you wanted ships in and out, you were buying and selling, with the potential for some fighting on top.

London has always been under attack. There is the famously brutal attack of the British tribe of the Iceni against London, led by the female warrior, Boudicca, also known as Boadicea. The historian Tacitus (c. AD 56–117) sets out what happened. The Roman general, Gaius Suetonius Paulinus, did not know whether to stand and fight or retreat. He had fewer troops than the enemy, so he sacrificed Londinium to save the province as a whole. He told the inhabitants he was leaving. Those who stayed because they were women, old or attached to the place were slaughtered by the Iceni. It was an almost-annihilation: London from this period is an archaeological level of red dust. That was in about AD 60. London had existed for only about ten years.

The Romans had their revenge. It is claimed that in return they slaughtered 70,000 Britons at the Battle of Watling Street, perhaps near modern King's Cross. All we are told by Tacitus is that Suetonius found a place with narrow jaws and a forest behind it for his killing field.

Then London burnt down. In AD 122, about the time that the Emperor Hadrian visited London (the bronze head of his statue in the British Museum is a masterpiece), there was a great fire and London had to start again for the second time. There is evidence of villas, baths and public buildings. The population may have made it to about 60,000 at its height. Today, the population is over 8 million. And you wonder why it takes an hour to get anywhere.

It seems that the comparative scale of destruction was similar to that of the Great Fire of 1666. That one began when a maid forgot to put out the fires in one of the king's bakeries in Pudding Lane. We don't know the cause of the Roman fire. In 1665, the Great Plague in London wiped out a vast number of the population and caused King Charles I to flee the city. In a strange way, then, London was lucky. The fire pretty much finished the plague off in 1666, sweeping through the poorer areas that were full of rats covered in plague-infested fleas. Roman London doesn't seem to have had things this way round. First it burnt down, then the plague came towards the end of the 2nd century AD. This was the Antonine Plague (named after the Antonine Emperors) that swept across Europe between AD 165 and 190. This provides a possible explanation for the dramatic slump in London's population and physical size at this time.

Between AD 190 and 225, the Romans built a defensive wall around the city. In itself, defence is rarely a good idea in the ancient world: instead, being on the attack means that your borders are further away and the enemy is busy there, not taking over your city. This might also be a reason for the London slump. Not only are you sitting there, waiting for someone to attack you behind your wall, but a lack of the bang-crash-wallop of an expanding and exciting city is a massive dampener on trade and economic growth. One interesting point remains: the modern financial City is pretty much defined by the scope of the Roman wall, some of which can still be seen from the Museum of London.

Roman London seems not to have recovered properly from this crash. Archaeology has identified dark earth that remains undisturbed: that is not the sign of a flourishing population. The one thing that seems to have given a temporary boost to London in the 3rd century was when the Romans, under the Emperor Septimius Severus, decided really to fight again, this time against Caledonia: Scotland. Hadrian's Wall (begun AD 122) was the defensive line that marked the Scots out as having their own way. By absorbing lands beyond that, London's favourite thing could happen again: an expansion in trade.

Of course, what always seems to screw up prosperity is politics. After this time, London had periods when it flourished, but also periods of political infighting, usurpers and invaders. What was it that did for Roman London in the end? A lack of trade and money.

The amazing things you can do with concrete

It is the C-word. Concrete. The horrid grey stuff that seems to be poured constantly over city centres and the country-side in order to boost the economy or create affordable housing. It is often seen as a cheap and nasty way to build something that could have been done in a much nicer way.

In fact, concrete is amazing stuff. Vitruvius, a Roman architect, wrote about it at length, discussing the various types that were used for different projects. The Romans invented it, and it changed the way we build things forever.

Concrete was sometimes used in building Roman roads. I know hardly anyone who got through school without having to draw a cross-section of a Roman road. I know I had to several times, and it never got any more interesting, as it was a copying exercise, not an investigation. It is the sort of thing that can give Classics a bad name.

Roman roads are actually quite interesting too. One theory suggests that they are the reason that Christianity spread throughout the Roman Empire: you could travel long distances safely, and so spread your message very easily. They explain how the army could travel fast, for instance to put down rebellions. As Bill Clinton rightly put it, the answer to more or less everything is 'the economy, stupid'. Roads brought trade and money.

That is just one use of concrete. Another masterly one was in arches. The Egyptians, Persians and Babylonians, for instance, had used arches as support structures under-ground. So, the Romans didn't invent the arch, and it was

probably the Etruscans who first brought them above ground. But the Romans certainly made them their own.

Arches are amazingly strong. A curved arch shows only half the stresses that you would find if you used two uprights and a horizontal lintel. The shape of the arch causes its weight to 'compress' it, rather than bend it, as it transfers the thrust force acting on it to the columns or piers supporting it. This means that an arch is always in the incredibly strong structural state of compression. The hidden trick is to keep the path of thrust within the arch to avoid bending and to have supports capable of resisting the horizontal component of the thrust force.

Arches were built of concrete alone or stone with a concrete core for added strength. Building a concrete arch began with precise carpentry to create a wooden template that was supported by wooden scaffolding. The template had to be exactly the correct shape, as it served as the shuttering (or 'formwork') for the concrete that was poured into it; and it had to be strong enough to hold the concrete until it set. A timber construction was also used as the working frame for stone arches, made from tapered stone blocks, with the crucial keystone in the centre that locked the arch in place.

Of course, one arch can be an impressive thing, and the Romans realised this when they built Triumphal arches to celebrate victories, such as the Arch of Constantine in Rome (The Arc de Triomphe in Paris is a 19th-century arch, modelled on Roman designs). However, if you put arches side by side, you can create different structures

altogether, such as arcades. And if you put them on top of one another, then you can span deep valleys, as with viaducts and aqueducts (and these needed precise engineering so that the water would flow).

But it doesn't end there. Imagine taking a round arch and spinning it on its vertical axis. You get a rotunda, or a dome. That is exactly what the Romans did when they built the dome of the Pantheon in Rome, the Temple to All the Gods. The dome is also built of concrete.

The Pantheon in Rome is the largest intact ancient Roman building remaining. The one we have is the second version – brick stamps reveal that this one was built by the Emperor Hadrian between AD 118 and 125 (think how quick that is) – as the first one burnt down in AD 80. But it has the dedication of the first by Marcus Agrippa, the friend of the Emperor Augustus:

M. AGRIPPA.L.F.COSTERTIUM.FECIT
Marcus Agrippa son of Lucius, having been consul
three times, made it

The Pantheon has been in use as a temple, and then a Christian church, ever since it was built.

When the Romans built the Pantheon, what they made was a celebration of their engineering knowledge of arches and the subtle use of different grades of concrete.

Arches are the ribs in the construction of the walls of the Pantheon. Layered up one on top of another, they worked against the settlement or creep of the concrete

over time, so that building could proceed quickly. Their traces can be seen within the masonry of the outer walls. They bear loads and redistribute them down to the foundations. This is one reason why the Pantheon is still in one piece.

The Pantheon still has the largest unreinforced dome in the world at 43.4m in diameter, about a metre larger than St Peter's Basilica, but St Peter's had to be supported with an additional five iron rings built in the dome following a detailed survey and a mathematical analysis of thrust. By 1742, the two rings in the dome were no longer strong enough to cope.

Domes have different stresses to arches. There are hoop pressures that run compression horizontally in circles around domes, as well as the stresses that work vertically from the top to the base. The pressures have been dealt with very cleverly in the Pantheon. And concrete was the key.

Concrete was made by mixing a strong volcanic material (called *pazzolana*) with rubble, sand and a slaked lime. It was only in the 19th century that someone devised a better mixture when they came up with the Portland cement that we still use. Roman concrete could even set underwater, like modern cement. What you need to do to make concrete is to get the silicon in the sand to bind chemically with the calcium in the limestone. Where Portland cement uses china clay, Roman concrete used the fine silicon dioxide in volcanic ash: something we are rediscovering today in the use and development of modern cement by using the blast furnace slag from steel production. There is really

only one reason that the 19th-century version is better than the Roman. Roman concrete had to be mixed on site – it could not be ground to a powder and stored in paper bags as modern cement can. When it is wet, slaked lime is very dangerous (it is extremely caustic), so it had to be kept in sealed pots.

The dome of the Pantheon is a testament to brilliant building when there was no heavy machinery to help. There is also a bit of engineering magic. Think of a masonry arch – if you take out the keystone, the whole thing will collapse. The utter genius of the Pantheon is that there is a circular hole, the *oculus* ('eye'), nine metres in diameter, right at the centre of the dome. It is not just that the Romans pulled off this trick, but that they knew that the hole made the dome, counter-intuitively, *stronger*. The original bronze flashing is still in the oculus, as are three rows of wedge-shaped bricks – the only masonry in the dome – and they form a compression ring to help hold the pressures pushing on the centre of the dome.

What about the rain and snow that falls through the oculus? It falls in a perfect circle to the slightly concave tiles below, which have holes in them, taking the water to the Roman sewerage system (something else the Romans invented).

The dome is so strong because the concrete is thinner at the top and thicker nearer the base; also near the oculus it is lighter in density and heavier in density nearer the base. This all allowed the Romans to make it so very, very large. For the concrete around the oculus, lightweight

volcanic stones were used as the aggregate, while at the base, heavy granite was used. Different aggregates are still used in a similar way in modern construction. The base of the dome has added brickwork to resist the thrust forces of the dome pushing outwards. Finally, the dome is made even lighter through coffering: rectangular sections, with three or four recesses, have been removed all around the inside of the dome. This also brings a perceptual lightness for the viewer.

The dome was probably built by setting up a huge wooden hemisphere, supported by wooden scaffolding. Rings of concrete could then have been poured, with concrete ribs. There is a story that it was in fact built on a massive pile of earth to which Hadrian had added pieces of gold – so that the workers would move it quickly when it was finished!

Why was the Pantheon built at all? It certainly does not follow the usual floor plan of a Roman temple. Speculating on this can make people go a little whimsical, with some even suggesting that, because of the sun shining through the oculus, it was built as a massive sundial. An interesting fact about it is that the rotunda's internal geometry creates a perfect sphere. The height of the rotunda to the top of its dome matches its diameter. It is as though a mini globe could be set inside it. However, I think the most marvellous thing of all is that it *was* built, *then*. That the Romans had the necessary grasp on the engineering needed and had the guts to build it is much more inspiring than a sundial.

A secret message

Whether we think of being in the back row at school pass-
ing slips of paper to our friends, or of secret codes, spies
and warfare, there has always been a place in the imagina-
tion for secret messages.

No one did it better than Histiaeus in about 500 BC,
when he sent a message to Aristagoras, the deputy governor
of Miletus, a city on the coast of Anatolia, modern Turkey.
They were at the heart of the Ionian Rebellion, in which
Greek cities from Ionia, along the east coast of the Aegean
Sea, banded together to try to get rid of the Persians who
controlled them.

The Greek historian Herodotus, the 'father of history'
(c. 484–425 BC) who was also from Turkey (Halicarnassus,
modern Bodrum) tells his story in book five of his *Histories*
(which was a surprise modern bestseller after it featured in
the film *The English Patient*).

The *dramatis personae* of this tale are Aristagoras, the
nephew and son-in-law of Histiaeus, Histiaeus himself
(the former tyrannical ruler of Miletus) and the Persian
emperor, Darius I, who gave Histiaeus Miletus to control
for him.

Histiaeus and the other tyrants who were subject to
Darius had taken part in an expedition against Scythia
(north-east Europe and the area around the Black Sea).
Histiaeus had tricked the Scythians into thinking that
they were all leaving, by pretending to demolish a bridge
that they had been building across the Danube. He also

persuaded them to look for the Persian forces elsewhere, in this way leaving the Danube undefended.

After this triumph and some settlement-building, Histiaeus ended up as an adviser to Darius in the city of Susa (in the Zagros Mountains, 160 miles east of the River Tigris). However, Herodotus claims that he didn't like Susa – it is pretty remote – and that he wanted to be tyrant of Miletus again, which would undoubtedly have been more fun.

Perhaps nothing has changed, because Histiaeus' answer to getting back into power was to instigate a revolt, in this case the Ionian Revolt. This is the best bit. In 499 BC, he realised he had to get a message to Aristagoras who was holding the fort for him in Miletus. Of course, any obvious message would have been intercepted, and there was no app for this yet. So, Histiaeus shaved the head of the slave he trusted the most, tattooed a message on his head and waited for his hair to grow back. The slave was then sent to Aristagoras with the message that he was to shave his head. The message told him to revolt against the Persians. Surely, the best secret message in history.

This is how the story ends: the Greeks were more than delighted to get involved in some Persian-bashing, so the Athenians and Eretrians helped Aristagoras burn Sardis.

Histiaeus was always the trickster and pretended that he had absolutely no idea about what was going on, but nobly offered to go and put down the revolt for Darius.

Amazingly, Darius let him go, but one of Darius' satraps (provincial governors), Artaphernes, had a bit more about

him and guessed what was going on. Eventually, Histiaeus had to flee to Byzantium (modern Istanbul: interestingly a corruption of the Greek *eis ten polin*, meaning 'to the city'). Histiaeus didn't get back to Miletus; in fact, he was caught and beheaded, and his head was sent to Darius. The Persians put down the Ionian Revolt.

Darius was tricked until the end. He didn't believe Histiaeus was a traitor and so gave him an honourable burial. It seems he never saw the tattoo.

> **Quóndam.** [Latin]
> Having been formerly. A ludicrous word.
> Samuel Johnson's
> *A Dictionary of the English Language* (1755)

How to eat like a Roman

We only have one Roman cookery book, *de re coquinaria*, said to be written by a chap called Apicius. It is a set of recipes compiled in the 4th or 5th century AD.

Apicius, whoever he was, suffered a fate similar to Hippocrates (pp. 79, 85): everyone who followed him took his name as a way of giving authority to their results. Nevertheless, we can see that there were recipes that look a lot like the ones of today. There are the 'let's cook with five ingredients' type, the ones that you are supposed to be able to cook in 30 minutes, and the serious gourmet ones.

Liquamen and *garum* can be seen in the Latin of the recipes. They are often referred to as a fermented fish broth and were used to enhance the taste of food, rather as salt is used now. So, think salted water if you cook any of this, then add flavour later.

Should you so desire, a starter, main course, wine and (a rare) dessert are set out for you below. Enjoy your Roman *haute cuisine* toga party ...

Stuffed dormouse

I admit that I've never fancied the thought of a stuffed dormouse, let alone cooked one. This is a real recipe from Apicius, not a joke. There is a special, edible dormouse, *Glis glis*, which those with an exotic palate, I believe, can still get hold of in parts of Europe. When it is fattened up, it can weigh over 300 grams.

isicio porcino, item pulpis ex omni membro glirium, trito cum pipere, nucleis, lasere, liquamine farcies glires, et sutos in tegula positos mittes in furnum aut farsos in clibano coque. (Apicius 396)

[The dormouse] is stuffed with a forcemeat of pork and small pieces of dormouse meat trimmings, all pounded with pepper, nuts, laser,* broth. Put the dormouse thus stuffed in an earthen casserole, roast it in the oven, or boil it in the stock pot.

* Laser is a herb that is now extinct; it was perhaps like asafoetida.

Ostrich boiled in stock

I also admit I have never tried to boil an ostrich. To cook a whole one cannot be a task for the faint-hearted. But if you want to have a go, here is the recipe:

in struthione elixo: piper, mentam, cuminum assume, apii semen, dactylos vel caryotas, mel, acetum, passum, liquamen, et oleum modice et in caccabo facies ut bulliat. Amulo obligas, et sic partes struthionis in lance perfundis, ete desuper piper aspargis. Si autem in condituram coquere volueris, alicam addis. (Apicius, 212)

A stock in which to cook ostrich: pepper, mint, cumin, leeks, celery seed, dates, honey, vinegar, raisin wine, broth, a little oil. Boil this in the stock kettle with the ostrich, remove the bird when done, strain the liquid, thicken with roux. To this sauce add the ostrich meat cut in convenient pieces, sprinkle with pepper. If you wish it more seasoned or tasty, add garlic during coction.

Rose wine

I guess this is rather like an alcoholic version of perfumed violet sweets, for those who remember ...

folias rosarum, albo sublato, lino inseris ut sutilis facias, et vino quam plurimas infundes, ut septem diebus in vino sint. post septem dies rosam de vino tollis et alias sutiles recentes similiter mittis, ut per dies septem in vino requiescant, et rosam eximis. similiter et tertio facies et rosam eximis et vinum colas et, cum ad bibendum voles uti, addito melle

rosatum conficies, sane custodito ut rosam a rore siccam et optimam mittas. similiter, ut supra, et de viola violacium facies, et eodem modo melle temperabis. (Apicius, 4)

Rose petals, the lower white part removed, are sewed into a linen bag and immersed in wine for seven days. Thereupon add a sack of new petals which are allowed to draw for another seven days. Again remove the old petals and replace them by fresh ones for another week, then strain the wine through the colander. Before serving, add honey sweetening to taste. Take care that only the best petals free from dew be used for soaking.

Nut cake

There are very few sweet recipes from Rome. This is one. Rather like an apple turnover cake, I think.

Patina versatilis vice dulcis: nucleos pineos, nuces fractas et purgatas, attorrebis eas, teres cum melle, pipere, liquamine, lacte, ovis, modico mero et oleo, versas in discum. (Apicius, 143)

Try patina as dessert: pignolia nuts, chopped or broken nuts (other varieties) are cleaned and roasted and crushed with honey. Mix in, beat well pepper, broth, milk, eggs, a little honey and oil ... [I would have thought you would need to bake it now]. Pour onto a plate.

Enjoy.

Alexander the Great in India

When we think of the classical world we usually think of it as essentially European, with maybe a slight glance towards the Near East. In fact, Classics is a global phenomenon, not least because it is taught in major universities all over the world in guises such as Latin, Greek, archaeology, history, philosophy, literature and classical civilisation, and the history of art and architecture.

What is astonishing is that the classical world itself was global. Alexander the Great (20/21 July 356–10/11 June 323 BC), the Greek king of the kingdom of Macedon, marched his army to India in search of the end of the earth.

He was an extraordinary man who was physically as tough as could be, ruthless and, in the end, an alcoholic. He was a man who founded a city after his favourite horse on its death, and who had for his tutor the overwhelmingly brilliant philosopher Aristotle (pp. 169, 178, 184). When his men were marching across the desert and dying of thirst, he refused to drink. He married three times, and did not eat for days following the death of his closest military companion, Hephaestion, who is said to have known all his secrets. Their friendship was so close it was compared to that of the Homeric heroes and lovers, Achilles and Patroclus.

The story of Alexander taking his army across the Indus is so remarkable that it really should be a myth, a tall tale. But it is not. To lead such an army then was an extraordinary task. You had to guarantee supply chains of food and equipment over thousands of miles, otherwise you

would all die. You had to rely on maps that became more guesswork than reality with every day. You had to deal with whatever kind of fighting you met on the way. And there were no calls to the president to sort it out when it all went wrong because that person, essentially, was you.

So, this is the story of an ancient 'president' who did the equivalent of getting into a rocket and going to Mars to see what it was like up there. Because he could.

The campaign for India began in 326 BC. Alexander took a fighting force that has been estimated at about 35,000, but, in addition, they would have to have taken along tradesmen and armourers, camel drivers and horse trainers, and women and children. Who could organise the coherent movement of so many people today? He crossed the Hindu Kush. He sent supply lines along the Khyber Pass. He pressed on through Swāt and Gandhāra and, probably just for the sake of it, besieged and then stormed the pinnacle of Aornos, modern Pir-Sar, just a few miles from the Indus.

In 326, after crossing the Indus, Alexander undertook his most famous, most costly, and last battle: the Battle of the Hydaspes River in the modern Punjab region of Pakistan. The Indians had elephants – they were huge, crushed people under their feet and terrified the horses of Alexander's cavalry. However, Alexander won, and his enemy, Porus, is said to have asked to be treated as a king would be in defeat. He became Alexander's commander, his satrap, there.

The claim is that Alexander thought he was about

1,000 miles from the end of the world at the Ganges River when his army mutinied. They could not stand the tropical storms, they did not want to face the elephants again, and, after years of campaigning, they wanted to go home to see if their families were still there. One of his chief commanders spoke for the army. Alexander realised his trip to the end of the earth was over and they set off back to Macedon.

But Alexander was not quite finished: on the way home, he pushed his way down to the Arabian Sea and explored the Persian Gulf. In 324, against the warnings of fortune-tellers and astrologers, he marched towards Babylon. Alexander died in Babylon, and no one really knows why. It might have been one alcoholic binge too many, typhoid, malaria, poison or old wounds. He was taken back to Macedon on a funerary cart.

This is the man who made it to the Ganges River with no heavier warfare equipment than cavalry. He was truly 'Great'. It is possible that his Macedonians still live on there.

The Kalash in Afghanistan are a remote tribe of blonde and red-haired people with startling blue eyes. They are said to be the descendants of Alexander's army. They wear amazingly beautiful festival clothes and are not strict on the segregation of women. They have been targeted by the Taliban for their liberal lifestyle. DNA analysis of this remote group in the mountains seems to suggest that there was a genetic mixing at about the time of Alexander's conquest. Perhaps Alexander's people are still at the other end of the world.

What you can learn from an oil lamp

Clay oil lamps are small bits of everyday pottery: a few are highly decorated, but most are plain and cheap and were as disposable as a cigarette lighter. They are ubiquitous at archaeological sites across the Mediterranean. They are also found in North Africa, Egypt and Britain, for instance. They are found wherever the Romans went.

The lamps provided a source of artificial light. Oil, especially olive oil, was added through the central hole, and a wick, usually made of a bit of twisted linen or papyrus, was put through a nozzle at one end. The most basic lamps were merely a moulded circle or oval of fired clay that had a kind of spout for the wick pinched at one end. The wick was set alight, and the lamp had to be tended for it to stay alight: if the wick wasn't pulled up and trimmed, the lamp would go out.

The provision of light is not all that lamps were used for. They had religious uses: they were often given as votive offerings, used in ceremonies and added as grave goods together with pottery and jewellery, for instance, put in burial chambers.

We can learn so much from them: they clearly were seen as important for the dead. Was it to give them some light on the dark side? If so, that teaches us something about attitudes to life and death. They were given as offerings at shrines. Does that mean that some gift of light was being offered to the gods and heroes?

Archaeologists love oil lamps. They reveal secrets. There is almost always a maker's stamp on the bottom of the lamp. We then know the workshop that produced it. From that, it is possible to come to understand distribution patterns of the same kind of lamp and the popularity of different types of lamp. This can tell us about trading patterns of the lamps and the oil that they burnt. For instance, lamps are found less frequently in Britain, mostly concentrated in areas where the Roman army were stationed. This is probably because the olive oil that was so cheap in Rome had to be imported long distances and so was far too expensive for most people in Britain. The study of their shapes and any decoration helps with precise dating, which, in turn, can help to date other artifacts found with them. The clay can also be analysed to trace its origin. If there are bubble marks in the clay, the lamp would have been made by being pressed into a mould. If not, it could have been made on a wheel or shaped by hand, so we learn even more about how it came to be.

There is even an oil lamp museum in Nakayama, Japan, which can be visited virtually at: www.itca.co.jp/museume, as well as many private collections of them all over the world. There is something about oil lamps. They were one of the most common domestic items, yet, because they developed over time and *were* so common and traceable, they can often tell us more about the lives of the people who used them than a golden necklace. That is what makes the study of them rather addictive.

An ancient Greek computer

In 1900, a group of Greek sponge divers were sailing home from North Africa when a storm struck. They were blown off course to the rocky, almost uninhabited islet of Antikythera, north-west of Crete. While there, they started diving to see if there were any more sponges. What they found was amazing: a sunken ship from about the 1st century BC, containing its cargo of many marble and bronze statues.

Once the authorities had been informed, the painstaking task of retrieving and cleaning all the artifacts began. Deposits had built up over everything as it had all been in the sea for so long.

The fishermen and archaeologists were delighted. Bronze statues are particularly rare, as so many of them were melted down so the metal could be re-used. However, the most extraordinary find of all was spotted months after the excavation. Small gearwheels or cogs with Greek inscriptions on them had been found in the remains of a wooden box. The argument began about what this was, who made it and when.

The divers had found the most astonishing piece of technology to have come from the ancient world. Nothing so complex is seen again until geared Islamic calendars from about AD 1050 and the 14th century AD when mechanical clocks began to be made in medieval Western Europe. What they found is an analogue computer. Really, it is – because

it was used to make complex calculations, specifically about the cycles of the solar system.

Finding out the secrets of the *Antikythera Mechanism*, as it is now known, has not been easy. As the *Washington Post* remarked when reporting new information about it:

> Imagine tossing a top-notch laptop into the sea, leaving scientists from a foreign culture to scratch their heads over its corroded remains centuries later.
>
> Nicholas Paphitis. 'Experts:
> Fragments of an Ancient Computer'.
> *The Associated Press.* 1 December 2006

At least this computer was 'powered' by a crank handle. However, the laptop analogy is a good one. Imagine that time and the force of the sea had not left the laptop intact. How would you fit it back together, when you don't quite have all the parts? There have been several versions and reconstructions of the mechanism, which can all be seen via the Antikythera Mechanism Research Project. They started with a box of incredibly finely-worked gears, some with writing on them as we have seen. Another factor was that the sea had eroded many of the inscriptions. But, as with papyri (p. 136), modern technology came to the rescue through digital photographs, surface imaging and 2D and 3D X-rays to reveal more text and so give us more clues as to how the different gears fitted together.

The Antikythera Mechanism consists of three dials: one on the front of the mechanism and two on the back.

Various different pieces of information could be discovered by using the dials and their pointers. On the front is the Egyptian calendar. The second dial can be moved to make adjustments for leap years, and the signs of the zodiac are also set out. Mars and Venus are mentioned in the inscriptions, and the Mechanism might well have been able to calculate their positions, as well as those of the other three planets known to the Greeks (Mercury, Jupiter and Saturn). It seems that it could tell you the date and the positions of the sun and the moon, as well as the phase of the moon and anomalies in its orbit. It marked the rising and setting of certain stars. On the back, in a spiral, are various cycles used to fix calendars.

It is a work of genius. As a result, some find it hard to believe that this is the work of the Greeks from about 150–100 BC, even though others have linked it to the school of Archimedes (of *'eureka, eureka'* fame). As a result, if you look at the research website, one of the FAQs is: 'Was it left by aliens?' The answer is 'no'. In fact, it tells us something more remarkable than the time-travel of little green men. It points to the stunning technological advances made by the ancients of which we know so little.

But there are some hints in the ancient texts. The Roman philosopher, orator and lawyer Cicero (106–43 BC) wrote that the philosopher Poseidonius, his friend, had recently made a globe that showed the movements of the sun, stars and planets by day and by night. Archimedes had earlier made a model that imitated the movement of the heavenly bodies. The Mechanism is not a one-off. It is

part of a tradition of technology, observation and mathematics in the ancient world that is at least 1,000 years in advance of what we thought. One man who has worked on the Mechanism is Professor Derek de Solla Price. He claims that it:

> ...requires us completely to rethink our attitudes toward ancient Greek technology. Men who could build this could have built almost anything they wanted to. The technology was there, and it has just not survived like the great marble buildings, statuary and the constantly recopied literary works of high culture.

We don't know what the Mechanism was for: perhaps it was used in navigation, to predict eclipses, to understand the heavens or to teach. Or maybe it was just for fun. It doesn't matter – rather, what is important is that we have the tiniest hint of another aspect of the ancient world otherwise completely lost to us.

How to offend more or less everybody: the Emperor Elagabalus

Elagabalus (ruled AD 218–222) was fantastically dreadful. His story is of the kind that you can't make up because no one would believe you. It is hard to think of a part of society that wasn't appalled by him and his carryings on.

Historians have written of his 'unspeakably disgusting life'. What is even more remarkable, when you know the tale, is that he wasn't an old and depraved roué when a plot engineered by his mother and grandmother made him emperor. He was a teenager: fourteen years old when he took power, eighteen when he was assassinated.

Before he was swept to the imperial throne, Elagabalus was the high priest of the god Elagabal in Syria (his family had hereditary rights to that job). That is how he got his name, though he was only called it after his death. His grandmother was the sister-in-law of the earlier emperor, Septimius Severus (ruled AD 193–211), and his mother was the cousin of another crazy emperor, Severus' son, Caracalla (ruled AD 198–217: he ruled jointly with his father for a while), so Elagabalus was already in the jet set.

His mother was certainly a first-class schemer. She said in public that Elagabalus was the illegitimate son of Caracalla, so he deserved the loyalty of the soldiers who had once sworn allegiance to him. Then she showed the army how much money she had and, funnily enough, the Third Legion were on her side. The commander declared him to be emperor at sunrise on 16 May 218.

But it took a lot of bribery, political shenanigans and the Battle of Antioch (AD 8 June 218) before the previous emperor (Macrinus, ruled 217–218) was firmly defeated and Elagabalus was secure.

You might say that it all went wrong from that point onwards.

Deep down, the Romans were a conservative lot who

really liked winning new territories, having lots of money and trade and having someone sensible in charge. It was never going to go down well that the new emperor was an oriental priest.

But the Romans were also the first champions of PR. The equivalent of tweeting about your new image was to have a coin struck, if you were royal. That might not sound very exciting or important, but, if you think about it, coins are now much overlooked. It is completely ignored advertising space. Everyone has them. We don't even look at the images on them anymore, but in far-flung parts of the empire it was the most immediate way for everyone to know your face. And that you were in charge.

His grandmother, who also knew how to play the game, had a painting made of Elagabalus that was hung over the statue of Victory in the Roman parliament, the Senate house. Whenever the Senators made offerings to Victory, as they frequently did, by default they were making them to their new emperor-god too. And Elagabalus took on Caracalla's names – Marcus Aurelius Antoninus – as a way of tying his allegiance to his past.

It took until 219 for Elagabalus and his imperial entourage to reach Rome. Then it all went really wrong.

Elagabalus debased the coinage, and he allowed his mother and grandmother into the Senate (the first women there). But then he went too far: he tried to have his lover, the charioteer Hierocles, a blonde slave man, declared Caesar – one of the most revered imperial titles. Apparently, Elagabalus called him his 'husband'. His mother and

grandmother were trying to pull the strings from the back, as they must have grasped the nature of Elagabalus' character by now. But they couldn't hold him.

Elagabalus (remember he died at eighteen) managed to be married to women five times (men, maybe twice). The most scandalous marriage of all (to a woman) was to one of the sacred Vestal Virgins, and this outraged Rome at large. As you can guess, they really were not meant to get married: Vestal Virgins who strayed from the straight and narrow were meant to be buried alive. He said he wanted god-like children …

He also made up his own religion, based on the sun-god and his earlier priesthood to Elagabal: *Deus Sol Invictus*, the Undefeated Sun-god. He claimed he needed to be circumcised in order to be his own high priest, and he made the wretched Senators watch him as he danced around his own new altar.

But it seems that modern politics and the ancients were hand-in-hand on this one: it was the sex scandals that finally brought him down.

The historian, Cassius Dio, really doesn't have a good word to say about him. He claims he wore make-up (p. 14), shaved off his bodily hair and wore women's wigs. He also says that he liked playing prostitute and would do so in common brothels or taverns and in the palace itself: with everything set up beforehand for him to be successful. He could then boast about how much better he was at it than anyone else. He made sure his clients paid too.

He is also said to have talked about how much he

wanted to be called the 'wife' or 'mistress' of Hierocles, and promised doctors any amount of money if they could give him female sexual parts. They were a land of soldiers and traders, and although the Romans could put up with a lot, it was just a bridge too far.

It also became too much for his own imperial guard, the Praetorians. Even his mother and grandmother realised that he was a liability, so sought to get him ousted in favour of his cousin, Alexander. When Elagabalus cottoned on to the plot, he pretended that Alexander was about to die. The Praetorians went crazy and demanded to see Alexander alive. They cheered him, not Elagabalus.

Elagabalus was not pleased at all by their change of heart to him, so ordered that all the Praetorians who had been insubordinate should be executed. In response, they attacked him, while he tried to hide in a chest. He and his mother were beheaded, stripped naked and their bodies dragged through Rome. Hierocles didn't last either. Elagabalus also suffered the worst thing that could happen to an emperor after death: *damnatio memoriae*, a condemnation of his memory. All records concerning him were destroyed.

NOW FOR A SHORT WRITTEN TEST …

- Who was allowed to wear purple in Rome?
- Which Roman emperor married a nymphomaniac?
- What did the Romans use to get their washing white?

ART AND LITERATURE: A SMORGASBORD

This section contains some of the greatest stuff that anyone has ever produced. Look at it as a taster menu: an introduction to a whole world of literature that you never knew or had forgotten.

The problem with the parallel postulate

The Oxyrhynchus Papyrus 1.29
Courtesy of Penn Museum, Inv. no. 142655

The parallel postulate is the fifth postulate in the mathematician Euclid's (c. 300 BC) famous work of mathematics, *The Elements*. Euclid has been called the 'father of geometry'.

The first four postulates are taken to be self-evident, but it is said that the fifth was introduced at the point where Euclid could not prove it, but couldn't carry on without assuming it.

This is how it goes:

> If a straight line that falls on two straight lines makes the interior angles on the same side less than two right angles, then the two straight lines, when set out infinitely, meet at the side on which the angles are less than two right angles.

The idea is that you need to think of three straight lines. If two of the straight lines are cut by a third, when the interior angles add up to less than two right angles, the lines will meet.

Illustration of the parallel postulate

OK. Why on earth should we care about this? Well, it is bit of mathematics that has changed the subject forever.

There is a near equivalent (not logically so, as one can be true when the other is not) by the Scottish mathematician, John Playfair. Playfair's axiom can be used to

prove Euclid's and Euclid's can be used to prove Playfair's. However, his cannot be proved alone either. His is:

> At most one line can be drawn through any point not on a given line parallel to the given line in a plane.

For over 2,000 years there have been attempts to prove the parallel postulate, sometimes by reformulating it as Playfair did, but no one has ever done it.

Sir Thomas Little Heath, FRS KCVO KCB (1861–1940) was a civil servant, mountaineer and historian of ancient Greek mathematics. He wrote that Euclid's fifth postulate, 'must ever be regarded as among the most epoch-making achievements in the domain of geometry ... When we consider the countless successive attempts made through more than twenty centuries to prove the postulate, many of them by geometers of ability, we cannot but admire the genius of the man who concluded that such a hypothesis, which he found necessary to the validity of his whole system of geometry, was really indemonstrable.' Those geometers included the ancient mathematicians Ptolemy and Proclus, and the modern ones Wallis, Saccheri, Lambert and Legendre.

So, what do you do now? Well, really there are two choices. You can just keep going with the parallel postulate and then, of course, you have the system of Euclidean geometry. Or, you can do something radical: you can ditch it, and replace it with its negation. This is what Lobachewsky, Bolyai and Riemann did, as expanded by

Klein and Poincaré, so we end up with non-Euclidean systems of geometry.

What is so radical is that, depending on your system, the answer is different.

A way of looking at it is to consider two parallel lines, perpendicular to a third line, extending outwards forever.

If you are a Euclidean, those two lines will go on forever.

Non-Euclidean systems have another answer: 'hyperbolic' geometry has the lines curve away from each other; 'elliptic' geometry has them curve towards each other so that they cross.

It is a geometrical way of saying something like $1 + 1$ doesn't always equal 2.

The brilliant Gödel wrote his 'incompleteness theorem' with this kind of problem in mind. He states that in theories involving number theory, it is *impossible* to create a list of axioms that are totally consistent and complete.

This is not good if you are someone who wants completion and perfection, in the way that Plato did (p. 172). His system of the universe as understandable through the geometry of triangles is not going to give you pure knowledge. It just can't. It all depends on what you assume, as that determines what your triangles actually turn out to be like. It looks as though mathematics ends up with the same problem as ethics: if you construct a theory of the 'good', you always have to assume some principles to begin from. It doesn't seem as though geometry should have the same problem – but it does.

Hapax legomena: words used only once

When the Rosetta Stone (p. 148) was deciphered, the frequency and repetition of words helped. Repetitions allow for a full understanding of a word in different contexts and they allow for the mapping of patterns. But what if the word only occurs once?

A *hapax legomenon* is a word that is found only once in a body of work, its modern usage, or, in classics, only once at all. They can be surprisingly common. That does not mean that the word was rare at the time: the fragmentary nature of the transmission of texts from the ancient world has made many words come down to us only once. How do you deal with that?

Of course, it is often possible to work out the translation of a word by looking firstly at the grammar: you can tell from its form whether it is a verb, a noun, an adjective, etc. If it is etymologically connected to other words, then you can get even further because you know the basic root of the word, and then the context in which it is found can pretty much finish off the job for you. But, of course, some are much harder to deal with than that.

Hapax legomena are found in all sorts of texts. They cause a hoo-ha with some texts of the Bible, especially in Hebrew. There are *hapax legomena* in Shakespeare: in fact, some claim that you can determine the authorship of the plays attributed to him through the number of *hapax legomena* in the text, as each play has roughly the same number. But the winners are almost certainly the ancient Greek epics of

Homer, where there are said to be 1,097 *hapax legomena* in the *Iliad* and 868 in the *Odyssey*. They are found, on average, every 9.4 verses of the *Iliad* and every 11.8 of the *Odyssey*. Three-hundred and three words in the *Iliad* and 191 in the *Odyssey* occur only once in Greek. A special Homeric dictionary puts an asterisk next to them so you can spot them easily.

Some are of the technical sort that you can understand dropping out of literature: in the special kit used to yoke mules together, or as part of the description of a particular way of making a drink.

But they can also be incredibly powerful. One example from the *Iliad* refers to Astyanax, the son of the Trojan hero Hector. He is called 'Hectoriden', the son of Hector, only once. Hector is doomed to die, as is his son, at the hands of the Greeks after they sneak into Troy in their trick of the wooden horse. The boy is the son of Hector: that is precisely why he has to die. He is given this name just before he is slain. The potential of the baby son to grow up and seek revenge is something the Greeks didn't dare let slip through their fingers.

Hellenistic scholars puzzled over some of the meanings of *hapax legomena* too. They also realised that they could adapt these words to show erudition in their own poetry and even to conjure up a double picture: the one they were painting and a reminiscence of where the word was originally found.

The poet Apollonius of Rhodes (early 3rd century BC) worked in the library of Alexandria (p. 144) and

himself wrote a serious monograph on the works of Homer. However, he is especially famous for his fictional epic about Jason and the Argonauts and the quest for the Golden Fleece. He uses the Homeric *hapax 'amechania'*, meaning 'helplessness' or 'despair', as a common way of describing the luckless Jason during his travels while skirting, for instance, the danger of the snake-haired monster Gorgon, Medusa, wild seas and the dangers of love. The reference to Homer is telling. The word is used in Book Nine of the *Odyssey* when the hero, Odysseus, is also in despair as he is stuck in the cave of the one-eyed monster, the Cyclops, and he watches the monster eat his men one by one.

Of course, you were meant to be flattered by getting the reference, but you could also see that Odysseus is the one who carries his travels through to the end but has to watch all his men die. The despair of Jason, and his different style of persistence, gets most of the Argonauts home in one piece.

Roman poets wanted to get in on this literary allusion game, and Virgil, sometimes seen as the Latin Homer, was on its trail too. He took a Homeric *hapax* and then made a Latin version to connect him to the Greek and to show his Alexandrian sophistication. *Stomachos* in Greek means 'throat'. Homer uses it twice of sacrificed animals, but only once to refer to a human wound, despite all the fighting. Virgil uses it only once too to refer to a grizzly death by the sword.

Rare words are very interesting because they can be used to take a story or a point to a deeper level for those who

get it. But you have to get the reference. Just like the fact that there is no point talking football to someone who has no idea what you are on about, there is no point making complex literary references unless someone is going to get what they are. What this points to is that there was a large enough sophisticated readership who would understand what was going on when you used a *hapax*. Of course, we are talking about the classes who had the education and the time for sophisticated reading. But there were clearly enough of them to make references across time and languages worthwhile.

That heifer lowing at the skies:
the Elgin Marbles

A lot of people get rather jumpy about the Elgin Marbles, the sculptures that were taken by Lord Elgin, Thomas Bruce, from the Parthenon Temple in Athens and brought to London in 1806. Whether Athens or the British Museum should house them is a political hot potato that re-surfaces in the media every year or so. In fact, I am rather glad about the hoo-ha because it means that people actually care about some ancient art.

There is no doubt that the sculptures are extraordinary. They certainly had a great effect on the poet John Keats when he saw them in 1817. Their power made Keats aware of his own future death and also his connection with the classical past. He wrote 'On Seeing the Elgin Marbles':

My spirit is too weak – mortality
　　Weighs heavily on me like unwilling sleep,
　　And each imagined pinnacle and steep
Of godlike hardship tells me I must die
Like a sick eagle looking at the sky.
　　Yet 'tis a gentle luxury to weep
　　That I have not the cloudy winds to keep
Fresh for the opening of the morning's eye.
Such dim-conceivéd glories of the brain
　　Bring round the heart an indescribable feud;
So do these wonders a most dizzy pain,
　　That mingles Grecian grandeur with the rude
Wasting of old Time – with a billowy main –
　　A sun – a shadow of a magnitude.

For Keats and the rest of us, the Greek gods are displayed as intangible immortals in the Marbles, and we are sick eagles (the eagle is a symbol of freedom, but a sick one cannot fly). Battles and religious processions are captured in time in a way that makes us both yearn for the past and hope for the future. Keats can only feel sorrow for the fact that mortality limits his choices.

These days, the ability of museum conservators limits the mortality of the Marbles themselves: the Romantic poets realised that earthly objects, however well looked after, can only give us a hint of the true, eternal beauty they sought.

The Marbles have had a particularly hard life. The remains of the Parthenon, the temple dedicated to the virgin goddess Athena, can still be found on the rocky

outcrop of the Acropolis in Athens. It replaced one that was destroyed in the Persian War in 480 BC. Things have not gone much better for this one. In the 5th century AD, it was converted to a Christian church of the Virgin Mary. In the 1460s, it became a mosque following the Ottoman Invasion. It was also used as an ammunition dump by the occupying Turks: on 26 September 1687, it was ignited by the attacking Venetians, and the Parthenon was pretty much blown to smithereens.

It was in this state that Lord Elgin came upon it, with statues defaced by the ultra-religious and with tourists carving their names into the fragments on the floor or breaking bits off to take home as a souvenir.

Wherever you think the Marbles should be, you can't help feeling a bit sorry for Elgin himself. Born in 1766, at 29 he was already a lieutenant colonel in the British army. However, by 1798 he was completely broke, in poor health and without a wife. In an age when going abroad could really change your fortunes completely, Elgin got himself sent as an ambassador to Constantinople, modern Istanbul, together with his new, young heiress bride. The Turks were fighting the French at that point, and his job was to keep an eye on British trade and open it up further into the Black Sea.

However, Elgin had clearly picked the wrong place to be with his general state of ill health. He managed to contract rheumatism, asthma, syphilis (as Byron thought) and/or a particularly nasty flesh-eating disease that made his nose fall off.

Soon after the French surrendered in Cairo in 1801, Elgin somehow got permission to collect whatever he wanted from the Parthenon, including taking down statues from the temple itself. Despite this coup, Elgin's luck didn't really turn around: one of the boats he commissioned to take the statues back to Britain sank, and it took two years to rescue the sculptures on it from the bottom of the sea. Then the French and the Turks became friends again and decided it was time to wage war on Britain together in 1803. As he was in France, Elgin was held as a prisoner of war for three years.

Elgin, who had, really rather unsurprisingly, been unattractive to his young wife, came back to find her with another man and to discover that the Marbles were scattered across ports all along the coast. He went through a particularly scandalous divorce, and the British government refused to pay him back the expenses he'd accrued in getting hold of the Marbles. So, he ended up penniless again with the Marbles stored in his shed. They finally made it to the British Museum – he sold them to the nation for £35,000, less than half the amount it cost him to acquire and ship them – and the controversy about them has never ended.

It is a strange story: one of the purity and beauty of ancient statues, which were actually rather garishly painted by the Greeks. There are carved details of sinews and veins, in particular on the horses, that couldn't have been seen from the ground by the naked eye. Why are they there? To glorify the Parthenos (the great statue of Athena) or just because the sculptor could do it? Then there is the bad luck

of both the Parthenon itself and Elgin. Things are still not great between Britain and Greece on the Elgin issue.

Maybe we should look to Keats again for the joy and awe that the sculptures actually can bring. He revisits the Marbles at the end of his 'Ode on a Grecian Urn'. We don't know which one is the pot that he talks about, but it seems that the 'heifer lowing at the skies' is the one in the Parthenon frieze, trying to break away from the procession to the Athena Parthenos that is leading her to her sacrifice. Maybe the Romantics were right, and beauty really is truth and *vice versa*.

Who are these coming to the sacrifice?
 To what green altar, O mysterious priest,
Lead'st thou that heifer lowing at the skies,
 And all her silken flanks with garlands drest?
What little town by river or sea shore,
 Or mountain-built with peaceful citadel,
 Is emptied of this folk, this pious morn?
And, little town, thy streets for evermore
 Will silent be; and not a soul to tell
 Why thou art desolate, can e'er return.
. . .

When old age shall this generation waste,
 Thou shalt remain, in midst of other woe
Than ours, a friend to man, to whom thou say'st,
 'Beauty is truth, truth beauty, – that is all
 Ye know on earth, and all ye need to know.'

Prometheus: the trickster,
the hero, the literary model

A myth is an interesting thing because it is a story that can be retold to be, within reason, what you want it to be, to convey the message you want it to. One myth that encapsulates this is the myth of the Titan, half-man half-god, Prometheus, whose name means *Forethought*.

He is what you want him to be – the unfortunate one that gave so much to humans and suffered for them, or the one who sought rational solutions to the lot of humankind. Or just an old-fashioned charlatan.

There is a tragedy that, in my day, was claimed pretty robustly to be written by one of the great tragedians, Aeschylus (which is what they thought in the Library at Alexandria too), but others now cast this into doubt. It is called the *Prometheus Bound*. All manner of staging issues arise with it, not least because the main actor, Prometheus, is tied to a very large rock for the entirety of the play, and there was a rule when staging a tragedy that you could have no more than three actors. As half-man half-god, he presumably would be bigger than your average actor. Was he a kind of puppet with someone inside? Or is it all conveyed through the brilliance of the language?

What is more interesting is how he ended up there. The claim in the play is that Prometheus is being punished for two crimes against Zeus, the king of the gods: stealing fire from the gods (in a giant fennel stalk) and giving it to mankind, thus getting in the way of Zeus' plan to

annihilate the human race, as he'd had enough of us all. Another story about Prometheus is that he helped humans because he had first modelled them from clay. This is the noble Prometheus who takes pity on us and suffers for it. He suffers not just because he is tied to a rock, but also because the far-from-merciful Zeus has an eagle, one of his symbols, come each day to eat his liver, which then regrows each night. Why the liver? Because it was seen to be the seat of the emotions, and in this way Prometheus could suffer physically and also mentally.

Different stories are told about Prometheus by different authors. The poet Hesiod (sometime between 750 and 650 BC) turns the Prometheus story the other way around and writes about him as a cunning and cheap trickster who challenged the noble omnipotence of Zeus. He talks of the 'trick at Mecone': the gods and humans had arranged to meet at Mecone to work out the division of meat in sacrifices. After he sacrifices an ox, Prometheus divides it up. In one pile he puts the meat and the best of the fat, but he covers it up with a revolting-looking stomach. In the other pile he puts the bones covered up with shining fat. Zeus chooses the bones. Hesiod says that Zeus chooses the bones because he wants an excuse to hide fire from mankind, but the traditional version probably had Zeus being tricked, and he becomes so angry, he withholds fire from man. When Prometheus gives fire to mankind, Zeus sends Pandora 'of the deadly race and tribe of women' (and she was, in fact, the first woman) to earth as a punishment for man, and women are said to be good companions only

when you are wealthy. She carries a pot, or box, that when opened lets loose evils, pains and death-bringing diseases. Zeus *really* didn't like us.

What is unusual about Hesiod's story is that it gives us an aetiology, a reason, for why sacrifices were performed the way they were.

In fact, the *Prometheus Bound* tragedy was, not uncommonly, part of a trilogy, and it seems, from the fragments we have of the two remaining plays, that the trilogy ended with a Prometheus more like Hesiod's: he saves Zeus from being overthrown. He warns Zeus that he really shouldn't marry the sea nymph Thetis, as there was a prophecy that she would have a son stronger than his father. Instead, she is married off to Peleus, who searched for the Golden Fleece. Their son is the warrior Achilles of the Trojan War.

Prometheus is thus a complicated 'character', both villain and saviour, as slippery and difficult to pin down as his tricks.

That he can represent so many sides of life ensures that his myth lives on. Shakespeare alludes to it in the famous death scene of Desdemona in *Othello* through the imagery of the fire he stole. Othello knows that he cannot restore 'Promethean heat' to her body once it has been extinguished.

Byron wrote a poem about Prometheus (also entitled 'Prometheus'), looking, like other Romantics, at the various themes that could be drawn from the telling of his myth. This is the last stanza:

Thy Godlike crime was to be kind,
> To render with thy precepts less
> The sum of human wretchedness,
And strengthen Man with his own mind;
But baffled as thou wert from high,
Still in thy patient energy,
In the endurance, and repulse
> Of thine impenetrable Spirit,
Which Earth and Heaven could not convulse,
> A mighty lesson we inherit:
Thou art a symbol and a sign
> To Mortals of their fate and force;
Like thee, Man is in part divine,
> A troubled stream from a pure source;
And Man in portions can foresee
His own funereal destiny;
His wretchedness, and his resistance,
And his sad unallied existence:
To which his Spirit may oppose
Itself—and equal to all woes,
> And a firm will, and a deep sense,
Which even in torture can descry
> Its own concenter'd recompense,
Triumphant where it dares defy,
And making Death a Victory.

Prometheus was also seen as the figure who took technology too far and so brought disaster on himself and humans. Mary Shelley, for instance, added *The Modern Prometheus*

as the subtitle for her novel *Frankenstein*. Goethe used the Prometheus myth in a four-act lyrical drama that focused on whether he was punished rightly. Shelley thought the answer was no. Even Kafka wrote about various interpretations of the myth in his short story 'Prometheus'.

In music, Liszt wrote a symphonic poem on Prometheus; Fauré composed a three act opera.

In 2012, Ridley Scott released his film *Prometheus*. It is science fiction and focuses on one of the Promethian themes: the creation of man.

Prometheus has been the subject of statues, pictorial art, literature and music. His themes and adaptability make him as eternal as his character.

Ancient one-liners

Aristophanes (c. 446–386 BC) was the Greek comic dramatist who featured in Plato's *Symposium* (p. 199). Plato also criticised his (still extant) play *The Clouds* as it made fun of philosophers and rhetoricians who work to make the worse argument seem the better. Aristophanes had a wild imagination, in one play poking fun at the great tragedians, Aeschylus and Euripides, by making them compete against one another in a contest with a chorus of frogs. Aristophanes has been known as the Prince of Old Comedy, the genre he seemed to make his own, that relied especially on political slander and sexual innuendo. Here are some good bits from different plays:

Under every rock lurks a politician. (*Thesmophoriazusae:*
The women of the Thesmophoria, a women's festival)

Old age is a second childhood. (*The Clouds*)

A woman is very good at getting money for herself
and will not ever let herself be deceived; for she is
too accustomed to deceit. (*Assembly Women*)

You will never make a crab walk straight. (*Peace*)

A love of wine is the failing of a good man. (*Wasps*)

Do not use a blind guide. (*Wealth*)

Sex strikes: not just for the Greeks

The Greek version

Aristophanes' play *Lysistrata* (named after the chief char-
acter) was performed in 411 BC in Athens. In it, women
band together from all over Greece and decide to go on a
sex strike until the men end the Peloponnesian war that is
crippling Greece, as the Greek cities of Sparta and Athens,
plus their colonies and allies are tearing the country apart.

The play begins with a misunderstanding as they gather:

CALONICE: Tell me, Lysistrata dear, what is it you've
summoned this meeting of the women for? Is it
something big?
LYSISTRATA: Very.

CALONICE [*thinking she detects a significant intonation in that word*]:
Not thick as well?

LYSISTRATA: As a matter of fact, yes.

CALONICE: Then why on earth aren't they here?

LYSISTRATA [*realising she's been misleading*]: No, not that kind of thing — well, not exactly. If it had been, I can assure you they'd have been here as quick as you can bat an eyelid.

Trans. Sommerstein

Over a lot of wine, the women swear an oath to abstain from all sexual activity, including 'The Lioness on the Cheesegrater' (a sexual position which Aristophanes might have made up).

Then there is a shout as the old women seize the Acropolis, the citadel of Athens, which housed the Treasury, meaning the men have no more money to carry on the war.

When a magistrate turns up to try to get at the money to buy equipment for the war, he finds the blockade and complains that the men have not kept the women in check. He also accuses them of sexual promiscuity, alcoholism and being part of strange foreign cults. This is one reason why Aristophanes is so important. He's not only rude and funny, but he shows us a different perception of social life in Greece. There is the general impression that women were closeted away — just as the ideal picture of the Roman matron is seen on tomb stones: *lanam fecit*, 'she spun her wool' (*i.e.*, stayed at home and did as she was told). Aristophanes shows us something different, and

that includes a lurking male fear of what women could get up to.

He also sets out, via Lysistrata, how the women could run the City through the analogy of their working of wool:

> LYSISTRATA: The first thing you do with wool is wash the grease out of it; you can do the same with the City. Then you stretch out the citizen body on a bench and you pick out the burrs – that is, the parasites. After that you prise apart the club-members who form themselves into knots and clots to get into power, and when you've separated them, pick them out one by one. Then you are ready for the carding: they can all go into the basket of Civic Goodwill – including the resident aliens and any foreigners who are your friends – yes, and even those who are in debt to the Treasury! Not only that. Athens has many colonies. At the moment these are all lying around all over the place, like stray bits and pieces of fleece. You should pick them up and bring them here, put them all back together, and then out of all this make an enormous great ball of wool – and from that you can make the People a coat.
>
> MAGISTRATE: Burrs – balls of wool – nonsense! What right have you to talk about these things? What have you done for the war effort?
>
> LYSISTRATA: Done, you puffed-up old idiot! We've contributed to it twice over and more. For one

thing, we've given you sons, and then had to send them off to fight.

Trans. Sommerstein

Lysistrata is interesting socially, as she is prepared to take the men head on. This play is funny, but, more importantly, it was funny then too. There is the kind of humour that comes with the completely ridiculous, but she is not set up as a ridiculous character. The male fear is what is really funny: what if women were actually able to take part in politics? And what if they actually turned out to be *better* at it than men?

The magistrate questions her and she complains that women are stuck with the consequences of all the stupid things that men do, while the men don't listen to what the women have to say. She dresses the magistrate up as a woman, and then later as a corpse, because so many men were dying in the war and so many young women were just wasting away as spinsters at home: men can marry at any time, but women only have a short window of opportunity.

At this point, Lysistrata finds out that the sex strike is starting to break: the women are deserting their posts to go home for the most flimsy reasons, with a women who isn't pregnant pretending she is in labour, with a helmet under her clothes as a bump, and another even letting herself down from the rock of the Acropolis on a rope.

After Lysistrata has pretty much restored order, a man appears, desperate for sex. He is Kinesias, the husband of Myrrhine. Lysistrata tells her to tease him. So his wife tells

him that she can't have sex with him until the war stops. He agrees straight away, and they prepare for sex there and then. Myrrhine fetches a bed, a mattress, a pillow, a blanket and so on, teasing her husband to the final point. She then disappoints him totally by shutting herself in the Acropolis. The Old Men of the chorus sympathise with a sad song.

The play ends after more bawdiness about *huge burdens* with the appearance of *Reconciliation*, a lovely naked girl who charms the men into ending the war by her sheer beauty. The men and women argue briefly about war terms, but the sex strike is still upon them, so the negotiation period is brief. They all go to the Acropolis to celebrate, then dance drunkenly afterwards together. Peace is restored.

Aristophanes is unique. There is pure filth that made this author as an undergraduate blush, but she also laughed out loud in a silent library. For some jokes you need to know a lot about Athenian politics to even smile, but the obvious ones are the obvious ones.

> **bacchanálian.** *n.s.* [*from* bacchanalia, Lat.]
> A riotous person; a drunkard.
>
> Samuel Johnson's
> *A Dictionary of the English Language* (1755)

The modern versions
The media has recognised the link with the *Lysistrata*, as the sex-strike technique for getting men to do what you want is still going strong – but with mixed results.

Perhaps the most notable of the sex strikes was in 2003, led by Leymah Gbowee. She won the Nobel Peace Prize for her efforts in non-violent protests against the fourteen-year Liberian civil war. She later wrote that the strike had practically no effect on the outcome of the war, but what it did do was give the protesters international support against the warlords following media coverage of the strike.

On Mindanao Island, a remote part of the Philippines, violence between villages had become so prevalent that the main road had to be closed. This stopped the women selling what they made in a sewing cooperative. As a result, in 2011, they began their 'cross-legged movement'. The violence ended as the men put all their efforts into winning over their wives again.

There is also a sex strike going on at the time of writing. The Ukrainian campaign is entitled 'Don't Give It to a Russian': *Ne Dai Russkomu* (http://readrussia. com/2014/03/27/not-giving-it-up/). It is a publicity stunt designed to make Putin feel a little more uncomfortable, following the annexation of Crimea. Of course, as with the Liberian case, it is the sex strike bit that captures media attention. But it is a campaign against all things Russian – for instance, not to buy their goods. It is not expected to get the Crimea back for the Ukraine, rather it is portrayed as a huge joke. The slogan of the campaign is said to come from a poem by the Ukrainian poet Taras Shevchenko: 'Fall in love, O dark-browed maidens, but not with the Moscali [Russians].'

Perhaps the most extraordinary call for a sex strike

was by the Socialist senator (and gynaecologist) Marleen Temmerman in February 2011, as Belgium repeatedly failed to form a government. The BBC reported (http://www.bbc.co.uk/news/world-europe-12402838):

> 'I call on the spouses of all negotiators to withhold sex until a deal is reached,' said Ms Temmerman in an article for a Belgian newspaper. 'Have no more sex until the new administration is posing on the steps of the Palace.'
>
> She said if politicians' partners followed her suggestion, the 'palaver' of coalition-forming would be resolved quite quickly.

In the end, a Belgian government was sworn in on 5 December 2011, after 541 days of negotiations. Belgium had not had an elected government for 589 days. It is not clear if Ms Temmerman had anything to do with the resolution of the crisis. Much of Belgium seemed to suffer from a sense of humour failure about her suggestion. But it seems that another politician did not, again as reported by the BBC:

> Catherine Fonck, a francophone Christian Democrat senator, was quoted ... as saying: 'I do not want to take part in a sex strike. Politicians are not there to strike. On the contrary, politicians are there to arouse the country.'

Trimalchio's dinner party

The Romans enjoyed a good dinner party. So much so, it is known that they would go off and be deliberately sick part of the way through so that they could start eating and drinking all over again. Parties could be about expense and showing off and displaying your own importance.

Petronius (c. AD 27–66) would have known about this excess better than most, as he was an imperial courtier during the time of the Emperor Nero (ruled AD 54–68). Petronius was said by historians to be *elegantiae arbiter* (the judge of elegance) at the court, so lavish feasts would have been precisely his bag. Tacitus describes him as spending his days asleep, while his nights were the time when he carried out official duties or just enjoyed himself. He was an 'accomplished voluptuary', who nevertheless had a head for business when he conducted political work for the Empire.

He also seems to have been an author, as it is very likely that he is the Petronius named on a medieval manuscript as the one who wrote the *Satyrica*, a now fragmentary satirical novel set in about the time he lived.

He wrote about the seedier side of Roman life, pushing excess to the limit. This is seen exceptionally clearly in a section of the novel called the *cena Trimalchionis*: Trimalchio's dinner party. Trimalchio is a parody of the worst aspects of the Roman *nouveau riche*. He is brash, rude, tactless, stupid, excessively pleased with himself and devotes his time to making himself look as wealthy and fabulous as he can. There has been much speculation that Petronius was

thinking about the Emperor Nero when he wrote about Trimalchio.

Trimalchio (his name means 'three-times-king') is a freedman: a former slave who has amassed a fortune in business. His wife, Fortunata ('Lucky') had been a slave too and a dancing girl. Trimalchio claims he bought her out of slavery so that no one at a dinner party (like his?) could use her hair to wipe their greasy hands.

The dinner party is so over-the-top that it is vulgar. There are singing waiters and more and more exotic foods that seem to be designed to amaze rather than to taste nice. For instance, there are live birds sewn up inside a cooked pig that fly out when the pig is opened up. There are also dishes that represent each sign of the zodiac.

Trimalchio himself joins the party late, looking ridiculous: over-dressed and dripping with gold. While he behaves badly, generally ignoring his guests unless he is talking about how marvellous he is, the freedmen gossip about each other and how much money they each have.

Trimalchio is also excessively pleased with a tomb he has had made for himself ready for his death, commissioned from a well-known tomb builder called Habinnas, who happens to be at the party and shares the tastes and excesses of the freedmen there. Trimalchio's tomb is a monument to his lifestyle, rejecting everything that 'old money' and even a moderate education values. For instance, an inscription, 'he never heard a philosopher', boasts about his lack of learning, rather than the opposite.

Trimalchio becomes so drunk that he is delighted when his guests enact a mock funeral for him, of course based on excess and vulgarity (Would *you* be happy with that end to your dinner party?). This is the point about Trimalchio: he is a figure that we are meant *not* to want to be if we are the *elegantiae arbiter*. But Petronius understood such men, he understood Nero, and it seems that he could wind Nero around his little finger …

Until it all went wrong, of course, as it usually does with megalomaniacs such as Nero.

Trimalchio lives on in literature and film, most notably, perhaps, in F. Scott Fitzgerald's *The Great Gatsby*. The over-the-top parties that Gatsby hosts are seen to mirror those of Trimalchio. At the peak of his partying and fame, Fitzgerald writes: 'It was when curiosity about Gatsby was at its highest that the lights in his house failed to go on one Saturday night – and, as obscurely as it began, his career as Trimalchio was over.' He even thought of calling his novel 'Trimalchio'.

Petronius himself came to as sticky an end as Gatsby. In a world with a supreme emperor who had the ability to decide on life and death in an entirely arbitrary manner, Petronius probably got a little bit too cocky. The Emperor depended on his opinion a little too much. And everyone wanted to be the Emperor's best friend, not least the very powerful commander of the Emperor's personal guard, Tigellinus. He made up charges of treason against Petronius and forced a slave to give evidence against him. There was no chance of defence. Tacitus makes clear that

Tigellinus could do this by working on Nero's over-riding passion: cruelty.

Rather than wait to be killed, Petronius took his own life, as Seneca did (p. 191). This is Tacitus' description of his death from the sixteenth book of his *Annals*. Petronius played the game to the end:

He bore no longer the suspense of fear or of hope. However, neither did he throw away life with excessive haste, but, having made an incision in his veins, and then, according to his humour, bound them up, he again opened them while he talked with his friends, not in a serious manner nor on topics that were looking for the glory of courage. And he listened to them as they discussed light poetry and funny verses, not thoughts on the immortality of the soul or the theories of philosophers. To some of his slaves he gave generous presents, a beating to others. He dined, he indulged in sleep, so that death, although forced on him, might seem to be natural. Even in his will he did not, as many did when about to die, flatter Nero or Tigellinus or any other of the men in power. In fact, he set out fully the Emperor's wickedness, with the names of his male and female prostitutes and their novelties in debauchery, and sent the account under seal to Nero. Then he broke his signet ring, so that it might not be available in the future to cause danger to others.

Polycleitus: sculpture by numbers

Doryphoros from Pompeii *after Polykleitos,*
in the Museo Archeologico Nazionale di Napoli

There are many definitions of art. Unfortunately, none
of them works because something is always left out.
Expressionism looks to art as the expression of emo-
tion: as much as that works for a lot of music, it cannot
cover realistic portraits. Realism looks to hold a mirror to

nature, but that cannot cover symbolic or surrealist art. Clive Bell (1881–1964) looked to 'significant form', such that a Cezanne painting could display 'form', without even its subject being clear.

Polycleitus (5th century BC) defined art in a different way. He wanted a kind of 'form', but his was based on mathematics. He looked to understand the human form in a way reminiscent of Leonardo da Vinci's *Vitruvian Man*. Just as the philosopher Plato (p. 172) looked to the mathematics that he thought underlay the universe, so the sculptor Polycleitus looked to understand the human body and the ways it can move via mathematical formulae. What is rather remarkable is that it turned out to be highly successful.

One of his most prized sculptures is the *Doryphoros*: the spear-bearer. It is now lost and only Roman copies survive. It has been taken to encapsulate all that he tried to explain in his written work, the *Canon*, again lost apart from fragments, in which the 'rule' tried to explain the mathematics behind the perfect sculpture. All was based on the measurement of the finger and how that was copied and mirrored all over the body. But that alone doesn't lead to perfection. Archaic statues stand four-square and stare at you. Some are, of course, remarkable, but what Polycleitus wanted to convey in something made of metal, was the impression of life and movement.

That all focused on the Greek letter chi: χ.

The point is that there is a fundamental opposition, as seen also in the work of Heracleitus (p. 97), between the straight and the curved. This is the artistic equivalent of

the still and the moving. The body's natural reaction to gravity when in motion is seen in the way that there are weight-bearing and relaxed limbs in the warrior, perhaps Achilles, who is on his way to fight. It is all seen in the opposites of dipped hips and raised shoulders as the boy relaxes and walks. The spear-bearer also displays many more opposites: he is mid-way between fat and thin with an athletic physique; he is both naturalistic and monumental, warlike yet handsome.

The Platonic idea of a mathematics-based universe is seen at play here. The idea is that artistic harmony comes about from a precise equilibrium that can be explained in even moral terms as *to eu*, the good. *To metron*, the measure, was Polycleitus' way of leading realistic art into a new era, whereby that which cannot move looks as though it is about to leap off the plinth towards you.

NOW FOR A SHORT WRITTEN TEST ...

- How do we get the word 'barbarian'?
- Who acted in Greek plays?
- What was a hecatomb?

MAGIC AND MEDICINE: IS ANY OF IT RATIONAL?

We all love the thought of a miracle cure. But when is that because the brilliance of medical knowledge has found precisely what to do and when is it not explicable? There is a thin line between medicine and magic, as you have to believe in them for either to work. That is what is, in the end, really interesting: where does magic begin and where does rationality take over? How much of it is the placebo effect?

Spells ancient and modern

Most of this book is focused on some amazing achievements by the ancients, notably employing reason, mathematics and engineering. They built unrivalled buildings and brought rationality to medicine.

In general, too, we pride ourselves on living in a reasonable and rational world, one of law and order, science and research.

Before we get too carried away with this rational self-image, we need to explore those practices – shared between our ancient and modern cultures – that don't fall under the 'reasonable' umbrella.

Magic skirted the edge of medicine and religion: if you were looking to cure a disease, you might turn to medicines targeted at a particular disease through experience and reasoning, or you might turn to magic and its potions. The Asclepion shrines were dedicated to the god of healing, Asclepius, the semi-mythical doctor found in Homer's *Iliad*. In the shrines, people suffering from diseases, especially epilepsy, could sleep in dormitories filled with snakes in order to be cured by the god: Asclepius was pictured with a snake entwined around his walking staff. The strange thing is that it must have worked sometimes, perhaps as a form of shock therapy. To sleep in a room of long, brown (although harmless) snakes would certainly change me forever.

There is also a blurred line between spells to the supernatural asking for something and making an offering at the shrines of heroes.

Ancient spells usually have a different set of ingredients, though some are constant. The ones from Egypt could involve throwing a dead cat into the River Nile. But many include the same themes of love and violence (or disease) that can be seen in modern examples. Even the lyric poetess Sappho (p. 203) thought of love as causing harm and illness. And here again is another fuzzy borderline. At what point do we have a poem, a charm, a prayer or a spell?

Love spells from Greece often try to harness the loved-one's dreams. They are meant to go on a journey until they beat at the door of the lover, demanding to be taken in.

Or they can demand restlessness, sleeplessness or just the presence of the loved one instantly, as with one magical Greek papyrus that looks to the heat of the bathhouse as the heat of desire:

> Take a mussel shell from the sea and paint the figure of Typhon shown below on it, with myrrh ink, together with his names, in a circle, and cast it into the furnace of a bathhouse. When you cast the shell, recite these names written in a circle and add, 'Bring me (insert her name), whom (insert her mother's name) bore, today, from this hour, burning in her soul and her heart, quickly, quickly, now, now.'
>
> Daniel Ogden, *Magic, Witchcraft, and Ghosts in the Greek and Roman Worlds*

Revenge came anything but sweet. Again, in the mixing of magic and pharmacology, Pliny, in his *Natural History* relates: 'If the loins of a woman are smeared with the blood of a tick from a wild black bull, she finds sex repulsive ... and love too, if she drinks the urine of the goat, with nard [an essential oil] mixed in to cover up the vile taste.' Also, in Aquae Sulis, the modern city of Bath, where the Romans built huge public baths, curse tablets were pinned to the wall that basically hurled a horrible future on the people who had done the equivalent of stealing your towel. They wouldn't do that again.

Below is another spell. This time, it is a modern one.

Revenge

You will need:

- Something personal from your enemy (a lock of hair, their name written on a piece of paper, even a picture). This item must be preferably small and easy to burn
- A knife
- Two black candles
- One red candle
- Salt

Make a medium-sized pentagram with the salt, sprinkling it out on a hard, flat surface. Put the three candles around the pentagram in a triangle. Place the personal object of your enemy in the centre of the pentagram and triangle. Take your knife and use it to slice open your hand (it takes blood to get blood) and then let your blood drip down onto the item in the middle of the pentagram. Chant, 'Powers of vengeance, come to me. Cover me and help me destroy my enemy. Take them and take from them what they owe. Let my fury and my wrath show. Take my blood as an offering and do to them the harm that was done to me!' Light each one of the candles, starting with the red and then moving clockwise around until you light the last black. Then, take the red candle and, in the order that you lit them in, touch each of the flames to the object, setting it on fire. Put out each candle's flame with your blood. Now, let the item burn until it is nothing but ashes and the flames put themselves out. Now, harm will come to your enemy.

This is not the magic of children's parties with rabbits pulled out of hats and disappearing playing cards. Nor is it the tricks of a Houdini. This is really rather grisly, and you can see how it can lead the vulnerable to do all kinds of things. This is all far more like the ancient spells that also focused on revenge, love and money, the stuff that makes the world go round. So don't forget the modern ones when you read the ancient ones. Neither is actually funny.

The difference between the ancient and the modern lies in why you would turn to magic. The blurred lines between magic, religion and medicine make the spells of the ancient world just another means you might try to get what you wanted, whether it was a lover, revenge or being cured. Modern spells, however, seem detached completely from the usual ways we have of going about things and trying to reach our goals. But maybe these spells are, in fact, found on a similar continuum, when we think about the bizarre religious cults that some people sign up to and the unscrupulous side of alternative medicine.

The hysterical woman and the wandering womb

On the Tube the other day, I could not help overhearing an account of an argument, presumably about a now ex-girlfriend: 'She was completely hysterical', one man said to another. Sometimes, this phrase is seen as interchangeable with 'She was completely hormonal'. It might come as a

shock to find out what is really being said when you use the term 'hysterical', and what the notion has been used to justify when it comes to the way women have been treated.

'Hysteria' comes from the Greek word *hysterikos*, which means *from the uterus* or *womb*. Only women are hysterical. The Hippocratic text *Places in Man* goes as far as to say that 'the womb is the origin of all diseases'. So, on that reading, all diseases of women are hysterical.

Greek notions of anatomy were shaky at best due to a general taboo on dissection. Some analogies were made from animals – but it is very rare that we get to know how any anatomical knowledge was acquired. The members of Hippocrates' school were also not at their best when it came to the nature of the female body.

Perhaps their most extraordinary flight of the imagination was the *wandering womb*. The womb was said to go on various travels around the female body, thus accounting for symptoms in all sorts of unlikely places. It could reach your head or could wriggle all the way down your leg to cause a convulsion in your big toe. A dried-out womb is also said to have 'run' towards the moistness of the liver and so suffocated the woman from within. If a woman abstains from sexual activity, the womb may become dry due to the lack of moisture and so travel around the body in search of it. (Many Hippocratics operated within the structure of the opposites of hot, cold, wet and dry, with diseases often being seen to be caused by a disruption in their balance.) But how did the Hippocratics reach this explanation? A clear origin for this otherwise mad theory is that doctors

would have encountered a uterine prolapse (a slipping of the uterus from its normal position). One Hippocratic explanation that follows is that an overheated womb was searching for the cool outside the body. However, as Jacques Jouanna, an expert in ancient medicine, has made clear, the fanciful explanations of the wandering womb are more akin to magic than the rational accounts of medicine that we so often find in Hippocratic works.

If you thought that was bad, the therapies were worse. There were pessaries, some made from beetles; in addition, there was the treatment of fumigation of the womb, described in detail in *Diseases of Women*, a therapy that was used for centuries to counter suffocation of the womb. This is what happened: a clay pot was filled with dry garlic, oil and water, and the pot and a dish were made airtight. A hole was made in the bottom of the pot and a long reed placed in the hole and sealed. A hole was dug in the ground, large enough for the pot. It was boiled until red hot, then allowed to cool until warm, but with the vapour still rising through the reed. The woman then put the reed into the neck of the womb, which was 'fumigated' by the warm vapour (feeling queasy yet?). After all that, the woman was allowed to eat barley cake, wheat or boiled garlic. If she felt too weak to go through it again the next day, she had a day off, but it would happen again the day after, and again, for 40 days. The claim was that fumigation opened the womb up and made it upright, thereby stopping the 'suffocation'.

Even Victorian women carried smelling salts following the Hippocratic notion that the wandering womb reacted

to strong odours, and it would return to its proper place after the administration of the salts, allowing a swooning woman to recover.

The philosopher Plato (c. 428–347 BC) also got involved in discussions about the womb. In the *Timaeus*, a philosophical work that discusses the lost city of Atlantis and the creation of the universe (p. 172), he considers the origins of sexual activity. Just as when Plato discusses the nature of love in the *Symposium* (p. 199), he does so here by telling us a myth about the gods and early humans – so his account should probably be taken with a pinch of salt. However, what he said had long-lasting repercussions. He talked of the womb as a *zoon*, a living thing, an *animal* within the female animal. This has done women no good over the centuries, for the idea of 'an animal within an animal' left us prey to another kind of notion of the hysterical, not just one based on necessarily female disorders.

The animal within could be 'wild', and this could lead back to notions of hysteria that were linked with magic and the idea that women need to be tamed or controlled. One of the most notable cases of this notion was the Salem trials for witchcraft in Massachusetts in 1692. The trials focused, among other things, on whether the women accused of being witches were pretending when they exhibited intense convulsions, or whether they were possessed.

Where no physical cause for the hysteria could be found, the finger pointed to the devil. By the end of proceedings, over twenty people had been killed by the order of the law (nineteen were hanged, one pressed to death),

and five more died in prison. Linnda Caporael, a professor in Science and Technology Studies, claims that one answer to the Salem hysteria could be that it was a mass outbreak of ergot poisoning. Ergot is a fungus that grows on certain cereals, especially rye. It is highly likely that the villagers were eating such mouldy food. You can derive LSD from the ergot fungus. When the accused women screamed in agony or ecstasy, when they had visions or the men saw female demons, they might have been taking a poisonous version of the drug.

A psychological explanation, put forward by Marion Starkey, considers the hysteria to be the result of the repression of the girls within Puritan society.

Talk of hysteria came to a head in the 19th century. Émile Littré (1801–1881), author of the *Dictionnaire de la langue française,* philosopher and translator, is claimed to have brought about a notion of 'hysteria' as a single, catch-all, disease of women through his translations of the works of Hippocrates. Where there is the adjective, *hysterikos, of the womb,* in Hippocrates, he brought in the noun, *hysteria.* That, in itself, is not as important as the way he categorised the Hippocratic texts. He distinguished between the 'real' movement, or displacement, of the womb and the imaginary, a difference marked between organic disease and the invented – the hysterical in the 19th-century sense.

By the mid-19th century, some thought that a physical problem with the womb was the cause of hysteria, but others claimed that hysteria was something at the heart of being female itself. A French medic, Marc Hector

Landouzy, in his treatise on hysteria, asked, 'Can one safely marry a hysterical woman?' It took another French medic, Pierre Briquet, to start to think of hysteria as a kind of psychiatric disorder, a type of neurosis. Of course, this was fertile territory for Freud. His theory of the free-floating unconscious, the 'mind within the mind', also recalls the Hippocratic 'animal within the animal'. Freud followed on from the work of the French neurologist Jean-Martin Charcot, who considered hysteria to be a psychological disorder. Freud claimed Charcot had rehabilitated hysteria as a serious area of scientific study. Pierre Janet and Josef Breuer, pioneering psychotherapists, went back to the notion of the hysteric being split in two, but rather than being possessed, or ruled by a part of the body you could not control consciously, they analysed hysteria in terms of psychological concepts and traumas.

These psychoanalytical notions challenged a still-pervasive idea that had grown in popular appeal throughout the 17th and 18th centuries, that women had become depraved when they exhibited such symptoms, as they had left their proper channels of motherhood and their role as guardians of virtue. This was a moral notion of the hysterical, rather than one focussing on demonic possession, the biology of the uterus or the functioning of the brain.

Hysterics have been hanged as witches and treated as suffering from sexual disorders, and they have been subjected to electroconvulsive (electroshock) therapy. They have been considered morally wrong and also in need of psychoanalytic therapy. Modern discussions still focus on whether there is

an underlying organic disease that we just can't pinpoint yet, or whether 'hysteria' must now be deemed a redundant term consigned to the history of medicine. One thing remains important: there is no single notion of 'hysteria'. The meaning of the term has developed over history, but always with at least a nod back to its Hippocratic origin. It has been used as a tool to control women and to classify them as 'other'. Please think what you are doing when you call someone 'hysterical'.

As Helen King states in her book *Hippocrates' Woman*, this is a 'disease' of women, but it has been discussed and used almost entirely by men: 'The language may shift – the womb travels, vapours rise … – but the message remains the same: women are sick, and men write their bodies.'

The Hippocratic Oath

Considering that the Hippocratic Oath is arguably the most important document in the history of medicine, it is also striking that we know almost nothing about it. We cannot pin down its date (it was written sometime in the late 5th century BC), who exactly took the oath (every medical practitioner or only those belonging to a particular school or guild?) or what sanctions were imposed if someone broke the oath. Hippocrates, the so-called father of medicine, might have written it, or perhaps one of his students did, or perhaps it was written by someone completely different. We just don't know.

The Oath comes in several sections. It begins:

> I swear by Apollo the medic [the god of healing],
> and Asclepius [another god of healing, the son of
> Apollo], by Health, by Panacea and by all the gods
> and goddesses, making them my witnesses, that I will
> carry out this oath and covenant according to my
> ability and judgement.

It was said that Hippocrates was a descendant of a son of
Asclepius. In this way, the Oath is tied to the gods both
by each person swearing it and by the supposed lineage of
Hippocrates himself.

After this, the Oath demands that the new doctor treat
his teachers and instructors as though they were his par-
ents and that, if his teachers were ever in financial trouble,
they must be helped out. The new doctor must also treat
his teacher's family as his own and teach them the art of
medicine for free if they want to learn.

The Oath then turns to the ethical: the doctor will use
his skill to help the sick to the best of their ability and
judgement, but will never use his art to harm anyone or
for any wrongdoing:

> Nor shall I give a death-giving drug to anyone if I
> am asked to ... similarly, I will not give to a woman a
> pessary that will bring about an abortion. I will keep
> my life and my art pure and holy ...

There is an argument that the Oath states that only abortion-
inducing pessaries are ruled out, rather than all forms of

abortion. But the point about abortion comes straight after the refusal to administer death-giving poisons, so I favour the line that any intentional death, whether an abortion or euthanasia, was prohibited. Doctors always acted in the interest of life.

At the moment, it is virtually impossible to get a doctor to make a house call, even for a sick child. However, the ancient version of medical practice was almost entirely based around home visits, although there were some centres of medicine, such as the hospital of Asclepius on the Greek island of Kos. Of course, the privileged position of entering people's houses when they are vulnerable led to another section of the Oath:

> Whichever houses I enter, I will go in to help the sick,
> without any intentional wrong-doing or harm, above
> all refraining from all wrongs, especially the sexual
> abuse of the bodies of women or men, free or slave.

As we come to the end of the Oath, there is a section on confidentiality: that whatever is heard or learnt in the course of practice will be kept entirely private and never shared with anyone. The practical point underlying this is that if a patient thought their secrets might be divulged, then they might omit some information crucial for their treatment. It is also just about being decent.

The Oath ends by pointing out that the doctor who follows the Oath will have set a reputation forever for themself and the art of medicine, with the opposite for any transgressions.

This is a sophisticated document that looks at the different sides of the medical profession. It is not about just using the right drugs: it is about using them in the right way, with the correct amount of compassion and care while preserving life and always putting the patient first.

The Declaration of Geneva is a version of the Hippocratic Oath that was accepted by the General Assembly of the World Medical Association in Geneva. It was adopted in 1948 with a view to bringing ethics back to the forefront of the medical profession after the medical experiments of Nazi Germany. The revised version of 2006 reads as follows:

At the time of being admitted as a member of the
 medical profession:
I solemnly pledge to consecrate my life to the
 service of humanity;
I will give to my teachers the respect and gratitude
 that is their due;
I will practice my profession with conscience and
 dignity;
The health of my patient will be my first
 consideration;
I will respect the secrets that are confided in me,
 even after the patient has died;
I will maintain by all the means in my power, the
 honour and the noble traditions of the medical
 profession;
My colleagues will be my sisters and brothers;

I will not permit considerations of age, disease or
 disability, creed, ethnic origin, gender, nationality,
 political affiliation, race, sexual orientation, social
 standing or any other factor to intervene between
 my duty and my patient;
I will maintain the utmost respect for human life;
I will not use my medical knowledge to violate
 human rights and civil liberties, even under threat;
I make these promises solemnly, freely and upon my
 honour.

There are other medical oaths, of course, but it is strik-
ing that this one retains so much of an oath that is about
2,500 years old. It is not obligatory for students who gradu-
ate in the UK or US to swear an oath, but many do. There
are no sanctions *per se* for breaking the Oath in the modern
world, but breaking it looks a lot like malpractice, so the
law has taken on long-standing Hippocratic values too.

As one of the Hippocratic *Aphorisms* says: *ars longa, vita
brevis* – the art (of medicine) is long, life, short.

NOW FOR A SHORT WRITTEN TEST ...

* What was the blood of gladiators used for?
* Which part of the male body was used as a symbol
 of a good luck charm in ancient Rome?
* Why did a philosopher tell you never to eat beans?

WHEN THINGS GO WRONG, OR AT LEAST GET TRICKY ...

This section is about extraordinary people. Not ancient emperors, or the politicians or financiers in positions of power today, but some of the scholars, saints and believers who shaped society. These are people who, for good or ill, have changed history or the way we perceive it. In one way or another, these stories are all about the power of language and belief, and how, sometimes, it can all hinge on one little word.

In the beginning was the *Logos*

En archē ēn ho Logos, kai ho Logos ēn pros ton Theon, kai Theos ēn ho Logos (Koine Greek transliteration)

In principio erat Verbum et Verbum erat apud Deum et Deus erat Verbum (Vulgate)

In the beginning was the Word, and the Word was with God, and the Word was God (King James Bible [KJV])

The beginning of John's Gospel is a text that is still hotly debated. 'The Word' is generally taken to refer to Jesus, a view based on the interpretation of the term 'Logos' throughout the chapter. But what is Jesus: is He (the) God, or is He *a* God?

It all comes down to the word 'the'. In fact, the controversies that arise about many difficult texts, Christian and pagan, often stem from the different uses in different languages of little words such as 'the', 'and' or 'but'. The argument in a nutshell here is about a missing 'ho' (the) before the last 'Theos' (God). Is it missing because it is to be understood, taken for granted that it should be there? Or did John mean to say '*a* God' instead, as there is no word for 'a' or 'an' in Ancient Greek? If so, that makes Jesus *a* God rather than *the* God. If we plump for *a* God, that, in turn, means that Jesus does not have to be considered as an equal to God Himself.

The argument about 'the' and 'a' here had extreme consequences for many. It has led to heresies and martyrs.

The Greek of the Gospels was written in a type of Greek known as the *Koine*. It means 'common' Greek and was the language used in various forms across much of the Mediterranean into Roman times (the Romans wrote some decrees in *Koine*, so the largely Greek-speaking peoples they ruled would know the new laws) and versions of it were used up to the medieval period.

There are, therefore, differences between Classical Greek and the *Koine*, which also have to be taken into

consideration when reading the Gospels, as well as pagan texts written in this common Greek, such as Epictetus' discourses and Polybius' history. Greek is not just Greek: there are different types, with different rules.

Even Modern Greek has played this game of different versions of itself. *Dimotiki*, the language of the people (*demos*), is said to have evolved naturally from Ancient Greek. In the 19th century, *katharevousa*, the *pure* language, was created by the revolutionary leader Adamantios Korais, an ex-pat who spent most of his life in Paris, from a combination of Ancient Greek and *dimotiki*. It was the language of political life and scholarship. If you could not understand it, you could not play a part in public life. For political reasons, again, *dimotiki* became the official language of Greece in 1976, and *dimotiki* and *katharevousa* have combined to create Standard Modern Greek.

The Latin of the Vulgate was a correction of mistakes that had crept into earlier texts and a translation of the Greek and Hebrew of the Bible begun by Saint Jerome in AD 382. Latin uses neither the word 'the' nor the word 'a', so the Saint cannot help us here either.

What can seem like small points about 'a' and 'the' can form the crux of theological discussion. Even a few words can raise such complicated and interesting questions about language, translation and the interpretation of meaning. There are other important words in this little sentence that carry a series of different, although interrelated, meanings.

As a result, I want to make a few points about *arche* and *logos*.

The key meanings of *arche*, as the Liddell & Scott lexicon (p. 124) tells us, are *beginning* and *origin*. But it can also mean *first principle* or *element*; *the end or corner of a sheet*; or the *origin* of a curve, as used by Archimedes. It is used to mean the *branch* of a river or the *vital organs* of the body. There is also a more separate set of meanings: *power* or *sovereignty*, a *realm* or *empire*, *magistracy* or *office*, as in 'oligarchy' or 'monarchy'. It has even been used for the *power* of the heavens or of evil.

Logos is even more complicated. It can mean *computation* or *reckoning*; a *measure*, a *formula*, *tale* or *story*, *speech*; a *sum total* or *value*; an *account*, whether a financial one or a story; a *reputation*. It can be a *relation*, *correspondence* or *proportion*; an *analogy* or *rule*. It can mean an *explanation*, a *plea*, *pretext* or *case*; a *statement of theory*, an *argument*, a *debate*, a *thought*, a *rule*, a *law*, a *reason*. It is used also for a *tradition* and a *rumour*. It has been used for a *divine utterance* or *oracle*; the *subject* of a painting; a *grammatical phrase*, a *sentence*. And, of course, the *Word* or *Wisdom* of God.

In fact, the Liddell & Scott lexicon (p. 124) has nearly six columns dedicated to the word *logos*, quoting different authors and texts, showing how the word was actually used. The interesting point is how different types of text adapted the term to their needs: mathematical texts, for instance, would adapt its meaning to be able to make the mathematical points necessary, whereas someone writing about myth would clearly use the term in a completely different way.

The Ode to Man

We can see how the tragedian Sophocles played on this ambiguity in the famous 'Ode to Man' in his play, the *Antigone*. The chorus in the *Antigone* sing about various different aspects of human beings: their achievements, their power and their faults. They begin by stating that there are many *deinos* things in the world, but there is nothing more *deinos* than mankind. *Deinos* does not have an equivalent in English, and so it is incredibly difficult to translate; it is not possible to capture the subtlety of Sophocles' claim here in one word.

Deinos can mean *fearful, terrible, awful*. But it can have a positive meaning of *marvellously strong, powerful, wondrous, marvellous, strange*. It can also refer to the intellectual as well as the physical, with meanings such as *clever* and *skilful*.

This is the ode. Sophocles has covered all the meanings of *deinos* in it.

There are many *deinos* things, but nothing is more
 deinos than mankind.
This *deinos* thing attempts to cross the grey sea with
 a winter wind,
engulfed by the surge all around with wave
 overcoming wave.
It wears out the highest of the gods, the immortal
 Earth, that never rests from working her, pulling
 the plough back and forth year on year with mules.

Thoughtful man captures the careless tribe of birds,
 the herds of wild animals and the watery creatures
 of the sea in a net's meshy coils.
By his arts, he overcomes the undomesticated,
 mountain-climbing animal,
And he makes the shaggy-maned horse obedient to
 the bit
and the untiring mountain bull go under the yoke.

Man has learned speech and thoughts that are as
 swift as the wind
and a city-ruling temper. He has learned to avoid
 inhospitable frost and wintry shafts: he is
 all-inventive. He is never resourceless as he goes
 into the future.
It is only Hades [the land of the dead] that he
 cannot escape; but he has contrived to break free
 from serious illnesses.

Wise, in his resourceful skill, a thing subtle beyond
 belief,
this steals him sometimes towards the good,
 sometimes towards the bad.
When he honours the laws of the land and the
 justice of the gods to which he is bound by oath,
 then he prospers within his city. But he is without
 a city who, for the sake of rash gain, has dealings
 with ignoble people.

> May such a person never be near me at my hearth;
> nor may the one who does this thing think the
> same way as me.

<div align="right">Sophocles, Antigone, lines 332–75</div>

I suppose the moral of all this is not to take translations for granted: language can be so subtle that we need to really work out what someone is saying and be as precise as we can in our response. Also, it shows that different people at different times have used language differently. Just translating something doesn't mean that you have instant access to all the thoughts behind the words. No translation can capture the subtlety of *deinos*. Nor does it, by itself, reveal the mindset of the person who wrote it. For instance, you can see in the piece above that there is a tendency to think in opposites: the man with and without a city, wild animals and tamed animals, the working of the land and the terrible sea, the fear of sickness and the ability to overcome it.

More opposites

Heracleitus (c. 535–475 BC), the Greek philosopher whose work is preserved only in fragments, also wrote about *logos*. But this time, *logos* was the account of the way things are, the underlying nature of reality. He is the one behind the idea of the *unity of the opposites*: the notion that there are

natural limits to the way things are. His claim is that if there were no such limits, then that would open the door to chaos, as we and the universe would have no parameters within which to operate.

> God is day the kindly night, winter summer, war
> peace, being full hunger ... he alters just as fire, when
> it is mixed with spices, is given a name due to the
> scent of each.

These are the limits that the world operates between: there are the seasons and day and night. There is no more night than midnight: that is its limit. There are the four seasons that define the year.

Also, we need to recognise that there are different reactions to things and different perceptions of things, but that they too are within limits.

> The sea is the purest and most polluted water: for fish
> it is drinkable and healthy, for men it is undrinkable
> and destructive.

> Disease makes health pleasant and good.

> The road up and the road down are one and the same.

The last fragment is interesting, because the point is that it *is* and, at the same time, *is not* the case that the road up and down are the same. I live on a very steep hill. It really

is not the same thing for me to walk up the hill as it is to walk down it, but if you were talking about the stretch of tarmac, of course it is the same tarmac whichever way I'm walking.

A similar conundrum comes about when we look at one of Heracleitus' most famous claims: that you can't step into the same river twice. Well, the claim is nonsense at one level. I can step into the River Tawe in Swansea, get out and get back in again. There we are – I stepped into the same river twice. But there is another way of looking at it: think of the water flowing past your feet as you stand in the river. If you get out and get back in again, the water molecules that flow past you are completely different every time. Heracleitus might have been talking about change being constant. At no point will you ever stand in precisely the same set of molecules. But there are limits on that too: the riverbank also defines the extent of the river, the space within which the change takes place.

Aristotle comments on this passage and points to the invisibility for us of some changes. Think of water dripping on a rock: eventually, it will wear away the rock to the extent that we can perceive the change that has taken place over time, but we cannot perceive the minuscule change that must occur with each drop. We cannot see children grow, but they clearly do. The way we use language also changes over time, and while we rarely recognise the subtle changes as they occur, those changes have to be within the limits of our being able to understand each other.

Two serious misunderstandings

The Romans had a perfectly reasonable horror of any peoples who engaged in human sacrifice or cannibalism. However, it seems that they sometimes got it very wrong when recording such instances, probably listening too much to embellished stories and folklore. Two such cases are the accounts of the Druids on the island of Anglesey and the early Christians.

The attack on the Druids on Anglesey

The attack on the Druids was called the Menai Massacre by the Welsh clergyman Richard Williams Morgan (c. 1815–89): the Menai Strait separates Anglesey from the mainland. By this massacre, he refers to the slaughter of the Druids in AD 60/61 by Roman troops under the command of the general Gaius Suetonius Paulinus as part of the plan to conquer the whole of Britain. It was this attack that led to the uprising of Boudicca and her Iceni tribe and the burning of London (p. 14).

The attack followed general Roman practice. There were two main methods to subdue people to Roman power: assimilation (nice buildings, bath houses, trade and prosperity) or pretty much annihilation.

Unfortunately, the Roman historian Tacitus (c. AD 56–117) is the only source we have for the account of the battle and what the Druids were actually like. Tacitus talks of them as fanatics, with strange and unwelcome customs

and practices. In fact, the real reason for the attack was most probably that the Celtic religion bound the different tribes together politically and gave them an infrastructure. As long as Anglesey (Latin: *Mona*; Modern Welsh: *Ynys Môn*) flourished as the epicentre of Druidism, there would still be rebellions by the tribes, and this would threaten the continued spread of the *Pax Romana*, the Roman Peace. Tacitus himself mentions Anglesey as a haven for refugees.

The army crossed the Strait by building flat-bottomed boats. The cavalry either forded the water or, when it was deeper, swam alongside their horses.

The battle took place on the beach. Druid men stood in ranks with wild-looking women flitting between them. They were all said to look like Furies, goddesses of vengeance, as they wore black robes, had dishevelled hair and waved burning torches. A circle of Druids were also at the battle, and they called down curses on the Romans. The troops were so horrified by this, they were frozen to the spot. Tacitus even says they were wounded because they were too terrified to move. It took a speech from their general to get them going again (they should not be afraid of 'females and fanatics'). Then the Romans massacred the lot, enveloping the enemy in their own flames.

Of course, the next move in the Roman game was to set up a garrison to secure what had been won. Tacitus again seems to have listened to too many tall tales, as he says the

Romans did so as a pious duty. They cut down the Druids' sacred groves where they were said to have sacrificed captives on their altars, consulting their gods by looking at the entrails of the sacrificed humans.

Or, maybe Tacitus wasn't that wrong after all. Although other writers allude to the intellectual prowess of the Druids and the artistic abilities of the Celts, there seems to have been a dark side to Celtic life that might have centred on the Druids. The Gundestrup Cauldron is a silver vessel from Iron Age Europe (c. AD 200 or 300), and it seems to have been made by or for the Celts. It is masterly in its execution, and one interpretation of it is that it pictures humans being ritually drowned in a boiling cauldron. The captives of Cimbri, a Germanic tribe, are also said by the historian and geographer Strabo (64 or 63 BC – c. AD 24) to have had their throats cut over a cauldron.

Human sacrifice was certainly taking place in Britain. The most famous probable victim is Lindow Man, the body found in a bog in Cheshire, North West England. He had been hit on the head, strangled and his throat had been cut.

There is clearly a lot of the dramatic and, perhaps, fanciful in Tacitus' account. It was meant to be frightening and to portray the 'other'. The Romans were clearly concerned about the power and influence of the Druids – and perhaps about their strange practices too. It is interesting that the Romans only banned two religions: Druidic practices and Christianity.

The Christians as superstitious cannibals

One common misperception of early Christianity was that Christians were cannibals. On the face of it, this was not entirely unreasonable if you heard snatches of their rites and listened to gossip. In what became the Eucharist, Mass or breaking of bread and drinking of wine, the bread you eat is referred to as the body of Christ and the wine you drink as his blood.

The Christians were accused, as the Father of the Church, Athenagoras (c. AD 133–90) reports, of clandestine rites that involved promiscuous sex and the eating of human flesh. These were called the Thyestean banquets (Thyestes, as punishment for seducing his brother's wife, was invited to a meal at which he ate his sons) and Oedipean unions (Oedipus unwittingly married his mother and became the stepfather to his sisters). A papyrus held in Cologne describes rites – which some have taken to be in mockery of the Christians – involving the murder of a small boy, the removal and eating of his heart, and the drinking of his blood. Followed by sex. Of course, such rumours spread quickly, and the accusations became wilder and wilder.

You can also see why Pliny the Younger (AD 61–c. 113), the governor of the province of Bithynia (modern Turkey), called Christianity a 'superstition': the Christian faith was perceived to go against more or less everything the Romans stood for. It seemed to have more in common with magic (p. 75) than any religion that had come to Rome before. Later in the 2nd century, Celsus, a Greek philosopher, wrote that Jesus was a magician and a sorcerer.

Celsus even wrote a book called *True Doctrine*, arguing against the entire religion. The book is lost, but it must have been powerful stuff because what we know of it comes from a refutation written by the theologian Origen 70 years later. If no one were still reading it, or cared, Origen would have written something else.

Pliny, however, represents a lot that is good about the Romans, and so does his Emperor, Trajan. While they both clearly had no time for Christianity (Pliny called it a 'mad sect'), their response is, in Roman terms, measured.

Sometime in AD 112, Pliny wrote to Trajan, as he often did. He was running a province, but you still needed to ask the boss a few questions along the way. His famous letter, X.96, and Trajan's response are pretty remarkable, not least because they are the first mention of Christians by Roman writers.

Pliny needs to know if the Christians who have been brought before him can be executed for no reason other than their faith. He asks if the young should be treated the same as strong men, and whether there is room for repentance or mercy. He asks whether they are to be prosecuted for taking the name of 'Christian' alone, or for the (unspecified) crimes that were taken to go along with the name.

This is the first time that Pliny has had to deal with Christians in his court, so he tells Trajan how far he has got: he started by asking non-Roman citizens if they were Christians or not. He would ask again and again if they were Christians, and if they continued to say that they

were, he had them executed. They were punished for their inflexible obstinacy. And they were not Roman citizens, so who would really mind?

Actually, it wasn't obstinacy, at least not that alone. The Christians were following the teachings from Matthew 10.33: 'whosoever shall deny me before men, him will I also deny before my Father in heaven'.

Roman citizens themselves were treated rather differently. If they refused to deny the name of Christ, their names went on a list for them to be sent for trial in Rome.

Then the floodgates began to open. An anonymous pamphlet listed the names of suspected Christians. Of course, names could be on there for any reason that the pamphlet writer chose. In response, Pliny brought in a statue of the Emperor, who was treated as a god, and dismissed anyone who repeated a formula praying to the Roman gods and made an offering of wine and incense to the Emperor's statue. The accused also had to revile the name of Christ. As Pliny says, '*quorum nihil cogi posse dicuntur qui sunt re vera Christiani*: They say that those who are truly Christians could not be made to do any of these things.'

Those who did what Pliny asked were dismissed. But he had a greater problem that he needed Trajan's help with. When some did confess to being (former) Christians, they said that all they had done was to meet at dawn and chant verses to Christ as if to a god. They also bound themselves with an oath not to commit any crimes. After their ceremony, they would then meet to eat together in a totally

innocent way. However, they had stopped this following an imperial ban on all political societies. Pliny decided the only way to extract the truth was by torturing two deaconesses. His conclusion: *nihil aliud inveni quam superstitionem pravam et immodicam.* 'I found nothing else except a base superstition and a debauched and over-the-top cult.'

Pliny ends his letter by saying that the Roman temples were now being filled again, after being practically deserted. The interrogations of the Christians had clearly frightened enough people back to conformity.

In his reply, Trajan praises Pliny's actions, saying that in the case of the Christians, there can be no single formula for dealing with them. He tells Pliny specifically not to hunt out the Christians, and to spare and pardon anyone who is accused if they offer prayers to the Roman gods, however suspect their past might be.

The end of Trajan's letter is the finest bit of all, and explains why I think this exchange is so great:

sine auctore vero propositi libelli in nullo crimine locum habere debent. nam et pessimi exempli nec nostri saeculi est.

In fact, anonymous pamphlets that are sent out ought to have no place in any criminal accusation. For they set the worst possible example and have no place in our time.

When the Romans dealt with the Druids on Anglesey, they were destroyed because they stood in the way of military

and civic domination. The Christians were not standing in the way of anything. They were just a pointless sect, as far as the Romans could see at this point. Therefore, there was room for clemency and the rule of law.

Roman saints

There are more than 10,000 Roman Catholic saints. A significant percentage were martyred, some managed not to be. Here are some of their stories.

Aristobulus of Britannia

Aristobulus (his full Welsh title: *Arwystli Hen Episcob Cyntaf Prydain*; in Latin: *Sanctus Aristobulus Senex, Apostolus, Martyr, Episcopus Primus Britanniae*) was known as Saint Aristobulus (or Aristobule) the Old, an Apostle, Martyr, first Bishop of Britain.

He was one of the 72 first missionaries sent out to preach across the world by the early Christian Church. He doesn't appear to have had an easy ride and was frequently beaten and dragged through towns like a criminal. He is claimed to have met the death of a martyr at the formidable age of 99 in the Welsh mountains.

Catholic tradition claims he might be mentioned by St Paul and identified with Zebedee, the father of Saints James and John.

His feast day is 15 March.

John Cassian

St John Cassian (c. AD 360–435) is an unusual one. He is also known as John the Ascetic. He wrote mystical texts on how to perfect a pure heart and about the order to be kept in monastic life. He became a monk himself, bringing the practices of monasticism from Egypt to the West.

He was probably born in Scythia Minor, now Bulgaria and Romania, to a wealthy family. He had a sophisticated education and was fluent in both Ancient Greek and Latin.

He travelled through Palestine and Egypt, as a practising desert ascetic, following the three stages of *Purgatio*, *Illuminatio* and *Unitio*.

The aim of *Purgatio* was to gain control of the flesh. The ascetics sought to purge from themselves their lust, desire for possessions and gluttony. This could take years. During *Illuminatio* the ascetic monks tried to follow a path to holiness as revealed in the Gospels. *Unitio*, if you ever got that far, was when the soul of the ascetic was meant to bond as one with the Spirit of God in a mystical way. Often monks went alone into the desert to find the necessary peace for this stage, even though they would be old men by this time.

Cassian finally arrived in Constantinople (modern Istanbul), having run away, as he had found himself on the wrong side of a theological controversy. He sought the protection of the Patriarch of the city, St John Chrysostom, but, when Chrysostom was also made to flee, Cassian had to plead his case in Rome in front of Pope Innocent I because his Latin was better.

While in Rome, he accepted an offer to found

Egyptian-style monasteries (one for men, one for women) near Marseille in Southern France. His monastery and writings influenced St Benedict, the founder of the Benedictine monastic order.

Cassian got himself in a bit of trouble over the issue of Divine Grace that brings an individual to God. He thought the individual had to make a bit of effort too, and that went against the orthodoxy. He got away with it, and seems to have died a natural death, but although his influence has been strong, he is seen as someone to read with caution.

Cassian, like Augustine, was never officially canonised, but he is recognised as a saint (it took a while to set up a proper canonisation process): Pope Urban V called him *sanctus*. His relics are kept in Marseille in an underground chapel. You will find his right hand and head in the church of the Monastery of St Victor.

His feast day is 23 July.

St Augustine of Hippo

Augustine (AD 354–430) was born in Roman Africa and eventually became one of the most influential Church Fathers of the West.

For someone who still influences church thinking today through his most famous works, *The City of God* and *The Confessions*, you would never guess his early life. After a decent start, Augustine was sent to the North African city of Carthage at seventeen years old to continue his rhetorical education. While there, he got in with the wrong crowd.

Augustine became a Manichaean. Manichaeism was a religion that had begun in Iran and looked at the opposition between a spiritual world of light and a material world of darkness. Really, he was no different to many students away from home today. He lived a completely hedonistic life that focused on sexual adventures with both men and women. As Augustine famously said in his *Confessions*, this was the time of his prayer: 'Grant me chastity and continence, but not yet'.

At nineteen he began an affair with a woman, and she bore him a son. They never married because she was not of the correct class, and he later abandoned her, as he planned to marry an heiress, through the intervention of his mother. Leaving this affair apparently broke his heart; he later said that, because of it, he had a decreased sensitivity to pain.

Augustine then became a teacher of rhetoric, firstly in Carthage, later in Rome. By the age of 30 he was the professor of rhetoric at the royal court in Milan. It was the top academic job of the time and opened a door to a serious career, even in politics.

As we know, Augustine converted fully to Christianity. He heard the voice of a playing child that told him: *tolle, lege* ('pick up, read'), so he opened the Bible and read the first verses he came across. He says they were Romans 13.13–14, rather fitting considering his life so far:

> Not in rioting and drunkenness, not in chambering
> and wantonness, not in strife and envying, but put on

the Lord Jesus Christ, and make no provision for the flesh to fulfill the lusts thereof.

From that point on, he became a famous preacher and author, converting many to Christianity.

Just before his death, the Vandals invaded Roman North Africa, where he was Bishop of Hippo, in modern Algeria. After his death, the Vandals burnt the city down but left untouched Augustine's library and cathedral.

He is the patron saint of brewers, printers and theologians, and is venerated for the alleviation of sore eyes.

His feast day is 26/27 May.

St Fermina

St Fermina (or Firmina) is the patron saint of sailors and the Umbrian cities of Amelia and Civitavecchia in Italy.

She was born in Rome in AD 272. At the age of fifteen she escaped the city to flee the persecution of the Emperors Diocletian and Maximus. She sailed along the great river of Rome, the Tibur, to the city of Civitavecchia. Along the way, there was a violent storm, but it is said that her prayers calmed it down (that explains her link to sailors and the city).

She lived for two years in a cave and preached Christianity in the port. She later set off for the town of Amelia, in Luchiano, where she met with persecution and was martyred. Her faith was so solid that she converted one of her executioners.

Even today, the two towns of Civitavecchia and Amelia are twinned because of Fermina. The St Fermina relay races in April and November see runners go the 107 kilometres from Amelia to Civitavecchia and from Civitavecchia to Amelia, with supporting boats following and horns sounding. The racers 'exchange' the torches that had lit her votive candles.

Her feast day is 24 November in Amelia.

Genesius of Rome

Genesius had a pretty good time of it at the beginning. He was a comedian and actor who took part in plays that lambasted Christianity, especially for the Christian-hating Emperor Diocletian.

One day, it all changed. There he was, on stage, making fun of a baptism. Just another day in the office. At that moment, he had a conversion experience. He refused to take back his declaration of his conversion, so Diocletian had him tortured and beheaded.

It is likely that this is all a myth, due to a confusion with the lawyer Genesius of Arles, who ended up beheaded and martyred when all he wanted was to be baptised.

Genesius is claimed to be the patron saint of lawyers, barristers, actors, converts, comedians, clowns and musicians. Also of dancers, epileptics, printers and the victims of torture.

His feast day is 25 August.

Saints Pelagia

There are two Pelagias, and in the way that literature advances and the tales grow longer, they have sometimes been merged into one.

The one that is the most likely to have actually existed is Pelagia the Virgin (died c. AD 311). Saints Ambrose and Chrysostom preached in her honour. She came from Antioch, now modern Turkey, and was a martyr at fifteen years old for her faith. She was arrested by soldiers during a period of persecution of Christians, but before being taken away, she managed to get permission to change her clothes. To escape the inevitable dishonour that came with being raped by the soldiers, she threw herself from the rooftop into the river.

Her feast day is 8 October or 9 June.

The other Pelagia, who often gets mixed up with the first, was a very different kind of gal. She is claimed to have been a very beautiful actress and a dissolute courtesan. She had many lovers, servants and jewels. She is said to have passed, very provocatively dressed and surrounded by admirers, by the tomb of a saint called Julian whom some bishops were venerating (again, another day at the office?). The bishops all turned away shocked, apart from one called Nonnus. He was moved by her success in the work of Satan, while they made such slow progress in the work of holiness.

The next day, Nonnus preached and Pelagia walked in and asked for baptism straight away as she had a sudden fear of God. She gave all the bling away and lived as

a hermit on the Mount of Olives, dressed as a man. She became known as the 'beardless recluse'.

This is almost certainly a made-up repentance story, the sort of thing that some claim was written to liven up the monotonous days of living as a monk.

Her feast day is also 8 October.

St Valentine

It is a day you love, hate or love to hate. The date 14 February (we all know the feast day) strikes fear into the heart of almost everyone, as you are bound to do things wrong.

If you are in a new relationship, what do you buy, if anything? After twenty years in a relationship, can you let the gift-giving slip a bit, or do the flowers have to be even more elaborate? Or is it Cuban cigars or nothing at all? If you are on your own, the pressure of not having a partner with whom to exchange Valentine's gifts and greetings can be intense.

A certain Valentine is said to have married Christians in secret, so that husbands didn't have to go to war. Before he was put to death, he is also said to have healed the daughter of his gaoler, Astorius. Another story says that before his death, he signed a letter as 'your Valentine' as a final farewell.

As with a lot of history, things are not always what you thought they were. For instance, Pythagoras almost certainly is not behind the theorem that has his name; it is likely that a rather more talented student of his was interested in triangles and thought that the sum of the squares

on the hypotenuse were equal to the sum of the squares on the other two sides. Valentine was not who you thought he was. Sorry.

In fact, there seem to be various Valentines. One, notably, was a Roman priest martyred on the Roman road, the Flaminian Way, under the Emperor Claudius; another Valentine was a Bishop of Rome who managed to get himself martyred too. There seem to be no churches dedicated to Valentine, but from 1835, a Carmelite church in Dublin has claimed to house his relics.

Or it might all just be a love story because birds are said to come together on 14 February, as Chaucer believed:

> For this was on seynt Volantynys day
> Whan euery bryd comyth there to chese his make.
>
> *Parlement of Foules* (1382)

The Roman festival of the Lupercalia, when you chose a partner, also happened in February.

It might all be flim-flam and marketing now. But there really was some connection to love around at least one St Valentine. As Shakespeare put it:

> To-morrow is Saint Valentine's day,
> All in the morning betime,
> And I a maid at your window,
> To be your Valentine.
> Then up he rose, and donn'd his clothes,
> And dupp'd the chamber-door;

Let in the maid, that out a maid
Never departed more.

Hamlet, Act IV, Scene 5

In 1835, 60,000 Valentines cards are said to have been sent. In the present day, the US Greetings Card Association estimates that 190 million Valentines are sent every year.

The Anglican Church in the UK uses 14 February as a day to renew marriage vows.

His feast day: you know that already.

Interesting deaths

Diodorus Cronus, who was interested in the Heap Paradox, is said to have died of shame when he could not solve a puzzle that was set for him by another philosopher when he was in front of the King of Egypt, Ptolemy Soter.

Marcus Licinius Crassus, the Roman general who helped transform Rome from a Republic to an Empire, is said to have been put to death by the Parthians after losing the Battle of Carrhae: he was forced to drink a goblet of molten gold, as symbolic of his great wealth. Perhaps it is more likely that, after his death, the Parthians poured molten gold into his mouth as a message about the perils of a great thirst for wealth.

Heraclitus, a philosopher, tested out his theory that heat could stop the liquid of life escaping from his body. As a result, he sought to cure his dropsy by having his

followers cover his entire body in cow manure. It did not work.

Chrysippus, the Stoic philosopher, is said to have died of laughter after watching his drunk donkey try to eat figs.

Pyrrhus of Epirus, the master-soldier behind the term a *pyrrhic victory*, is said by the historian Plutarch to have died when an old woman threw a roof tile at him that knocked him out so that a soldier could kill him.

Empedocles, the philosopher, is said by the biographer Diogenes Laërtius to have died by leaping into Mount Etna to show his followers he had become a god. Apparently, a single smoking sandal was found on the rim of the volcano.

Milo, a wrestler, came across a tree that had been split open using wedges. To test his own strength, he tried to split the tree apart completely, using only his hands. His hands got stuck and so he could not defend himself when he was attacked and then eaten by wolves.

Valerian was (briefly) Roman Emperor from AD 253–259. He is the only Emperor to have been captured alive by the enemy, the Persian King Shapur I, after the Battle of Edessa. He is said to have been used by the king as a footstool. He ended up being skinned alive: his skin was stuffed with straw or dung and preserved as a trophy.

Aeschylus the Tragedian (c. 525/4–c. 456/5 BC) is said to have been killed when a tortoise was dropped on his head by an eagle that thought his bald head was a stone suitable for shattering the shell, so it could eat it. He is claimed to have been outside to avoid a prophecy that he would be killed by a falling object.

Draco (c. 620 BC), the Athenian lawmaker (of strict 'Draconian laws'), was smothered to death by the gift of cloaks and hats thrown at him by the citizens to whom he gave new laws.

The Christian Saint Lawrence (AD 258) was roasted to death on a huge grill during the persecution of the Emperor Valerian. It is said that he teased his persecutors saying, 'Turn me over – I'm done on this side'. He is the patron saint of firemen, firewomen and cooks.

The Roman emperor Titus is said to have died in AD 81 when a mosquito flew up his nose and attacked his brain.

NOW FOR A SHORT WRITTEN TEST ...

+ What does the historian Tacitus say that the Emperor Nero used as a source of light for his garden at night?
+ What were hoplites?
+ What was a trireme?

MODERN SCHOLARS, ANCIENT LANGUAGES

From the scholars who dug up a lost literature in an Egyptian rubbish dump to those who unlocked the meaning of hieroglyphs, these are the stories of talented people who pushed the boundaries. They did extraordinary things that resonate now, all while Alice sped down the rabbit hole.

Academics at war

This is a story about two extraordinary individuals: Edward N. Luttwak and Nicholas Geoffrey Lemprière Hammond, their contributions to ancient history and the outcome of modern warfare.

Edward N. Luttwak: a modern approach to Roman warfare

Luttwak is a contemporary military strategist who has worked with the American government and military in particular, especially the National Security Council, the Office of the Secretary of Defense, the US Navy, Army and Air Force, as well as NATO. Luttwak is partly responsible for

the notion of manoeuvre-warfare, in which enemy weakness and speed of manoeuvre, above all, are emphasised in order to attack the enemy in the centre, thus disrupting all their operations, then withdrawing to start a new line of attack. Luttwak talks of the possibility of tanks, transporters and trucks moving in single file deep into the heart of enemy territory undisturbed because of their boldness, attacking the centre of enemy operations.

He is also the one who introduced the concept of the 'operational level of war' to the US: it is a term derived from the Russian that signifies the level of command that deals with minute details of tactics under the umbrella of strategy.

Luttwak decided that there were lessons to be learnt from the ancient world. He wrote *The Grand Strategy of the Roman Empire*, which, period by period, examines the military strategy the Romans employed throughout the Empire. It has received book-length rebuttals from conventional ancient historians. However, for an undergraduate who preferred poetry to battles, this book was a revelation. It showed a way of analysing Roman military tactics through the eyes of a modern strategist. It explained a little more of why the Romans did what they did when it came to conquering so much of the Western world. It opened a way to understanding how people wearing helmets and carrying spears, marching twenty or more miles a day, were the same as us and had the same fears and exhilarations.

Looking at the wider field, writing in 1976, Luttwak begins his book as follows:

In our own disordered times, it is natural to look back for comfort and instruction to the experience of Roman imperial stagecraft ... The fundamentals of Roman strategy in the imperial age were rooted not in a technology now obsolete, but in a predicament that we share. For the Romans, as for ourselves, the two essential requirements of an evolving civilisation were a sound material base and adequate security. For the Romans, as for ourselves, the elusive goal of strategic stagecraft was to provide security for the civilisation without compromising the security of an evolving political order.

E.N. Luttwak, *The Grand Strategy*
of the Roman Empire (1976)

Luttwak analyses military tactics throughout the Roman Empire. Their battles are our battles. They might have had spears while we have drones, but the goals have to remain the same, as we remain the same:

We, like the Romans, face the prospect not of decisive conflict, but of a permanent state of war ... We, like the Romans, must actively protect an advanced society against a variety of threats rather than concentrate on destroying the forces of our enemies in battle.

Ibid.

In a world dealing with the pervasive threat of terrorism at home and abroad, there are answers to be found from the

Romans. We are not throwing spears at each other, but we are still doing what they were doing – looking at diplomatic and social means by which to stop the terror and make everyone work together. Just like them, it is carrot and stick. The carrot was Roman baths, sewers (imagine not having them), festivals and chariot races. The stick, well, that has always been the same.

Hammond of Greece

N.G.L. Hammond, called 'Nigel' irreverently by under-graduates, was one of the greats of ancient historical scholarship. He was, in fact, Nicholas Geoffrey Lemprière Hammond CBE, DSO, who was also awarded the Order of the Phoenix by Greece for his undercover work in World War II.

His is an amazing story of a man who loved ancient Greece. After growing up in Scotland, attending Fettes public school and achieving a starred first in the Classical Tripos from Cambridge, he decided that the only way to understand the remote ancient Greek historical sites was to walk to them, learning modern Greek on the way, so that he could piece together the fragments that were left to enhance our view of the ancient world. As a result, he became robust, dealing with hard walking alone through the Greek and Albanian hills, the fleas and the people who didn't want him there. He learnt Modern Greek fluently, could dress like a Greek and knew a bit of Albanian.

Then the war came. Hammond puts it beautifully in the introduction to his story of undercover war work, *Venture into Greece*:

> In 1938, the War Office asked all dons whether they had any special qualification in the event of war. I replied that I spoke Greek and some Albanian and knew north-west Greece and southern Albania very fully, because I had been making an archaeological survey of those regions since 1930. The call came in 1940, and after a minimal training in the use of explosives I was flown out to Athens on 7 June, only to be refused admission by the Greek authorities. They probably had some suspicion of my mission, which was to enter Albania secretly and instigate a rising against the Italians (they had seized Albania on Good Friday 1939). The Greeks were maintaining a strict neutrality at the time.
>
> N. G. L. Hammond, *Venture into Greece: With the Guerillas*, 1943–44 (1983)

'Hammond of Greece' went on to a distinguished war career: not only was he given military honours, but he was mentioned in dispatches twice. His was dangerous undercover work, sometimes dressed as a peasant, sometimes as a soldier, trying, through the use of explosives, to disrupt the work of the enemy. It is said anecdotally that he would compare the manoeuvres of the enemy to those of the ancient greats, Philip of Macedon and Alexander the Great.

Despite various debilitating illnesses at the end of the war, Hammond continued a sparkling Classical career, almost as though the war had never happened. He wrote over 130 articles, as well as, among other books, a three-volume history of Greek Epirus. A week before he died in 2001, he handed his publisher a book on the tragedian Aeschylus.

One man, Luttwak, lives in the modern world, but learns from the Romans. The other, Hammond, cared about the past and fought to keep Greece free. The modern and the ancient cannot be separated – sometimes even in individual lives.

Liddell and Scott: a Greek lexicon

'I really don't remember,' said East, speaking slowly and impressively, 'to have come across one Latin or Greek sentence this half that I could go and construe by the light of nature. Whereby I am sure Providence intended cribs to be used.'

Thomas Hughes, *Tom Brown's School Days* (1857)

Two men wrote a lexicon, Liddell and Scott;
Some parts were clever, but some parts were not.
Hear, all ye learned, and read me this riddle,
How the wrong part wrote Scott, and the right part
 wrote Liddell.

Anon. as quoted in the *Oxford
Dictionary of National Biography*

The first edition of Liddell and Scott's *Greek Lexicon* was published in 1843. In revised versions, it is still the seminal work used as an Ancient Greek-English dictionary. It now comes in three printed forms: the 'big Liddell' – the full work (with over 2,000 double-columned pages in *very* small type) – and two abridged versions known as the 'middle Liddell' and the 'little Liddell'. There is now also an online version.

The story of the creation of this amazing work encapsulates Classical scholarship of its time, the incredible learning and memory of individuals, their dedicated hard work and the Oxford of its day, with its often aristocratic and eccentric characters.

Henry Liddell (1811–1898) was most certainly aristocratic. His father (also Henry Liddell) was the younger son of a baronet (*another* Henry Liddell). His mother began life as Charlotte Lyon; her father was the youngest son of the 8th Earl of Strathmore and Kinghorn. In 1883, the Liddells' northern estate measured nearly 14,000 acres.

Of course, a boy with such a lineage had to be sent to public schools. He attended Bishopton Grove, near Ripon, followed by Charterhouse. He is thought to have said this about his school life:

> I do not think that any sorrow of youth or manhood equalled in intensity or duration the black and hopeless misery which followed the wrench of transference from a happy home to a school.

However, something good did come out of this despair: a Classical education such that when he studied in Oxford, Liddell is said to have had the best reports of any student ever in Christ Church. He stayed on as a tutor and became a priest too, before serving as the headmaster of Westminster School, then returning to Christ Church to be the dean. In the 1830s Liddell and his once fellow-student, Robert Scott, began work on the *Lexicon*.

Robert Scott (1811–1887) did not have the sort of ancestors Liddell had: his father was a Devonshire rector. However, he went to Shrewsbury School and gained a first class degree at Christ Church. In 1835 he became a fellow of Balliol, then its master in 1854. His final years were spent as the Dean of Rochester.

As suggested by the doggerel verse above, Liddell was seen as the true craftsman behind the *Lexicon*, but this may not be entirely fair. What is clear is that Liddell was the bigger character, the one who became the object of fun because of his tall stature, intelligence and, as will be seen, ability to misjudge a mood entirely.

Lord Redesdale – the forefather of the Redesdale lurking behind 'Uncle Matthew' in Nancy Mitford's *Love in a Cold Climate* (the one with the blood-spattered entrenching tool from the First World War and the instigator of the 'child hunt') – claimed that Liddell had no hold over Christ Church ('The House') in his early time as dean, basically because he remained a 'schoolmaster' after his Westminster days and treated the undergraduates as such. There were riots. Lecture rooms were gutted.

Nevertheless, Liddell loved Oxford, his family and the Lexicon. It is important to remember how this Lexicon was compiled. It would be a tricky programming job to use the *TLG* (the *Thesaurus Lingua Graecae*, a compendium of all known Greek literature, computerised) and something like a spreadsheet to begin this task today. But Liddell and Scott had only their own vast knowledge, derived from encyclopaedic reading, and the support of their colleagues (as when a new papyrus text was discovered, for instance).

No book comes from a vacuum, let alone the *Lexicon*. It was the proposal of an Oxford bookseller, D. A. Talboys. The basis would be the lexicon first compiled in 1819 by the German Franz Passow, which itself was based on earlier German scholarship. Liddell and Scott's lexicon was an instant, run-away success. The print run began at 3,000 copies. The sixth edition sold 15,000.

Even though the *Lexicon* is the standard work of reference for researchers, university students and beginners, and is the basis for all subsequent Greek lexica in different modern languages, the irony behind this story of dedicated scholarship is that one of Liddell's daughters became *far* more famous than him.

In July 1846, Liddell married Lorina Reeve. Together, they had ten children: five boys (two of whom died of scarlet fever in infancy) and five girls. On 4 May 1852, one of these girls, Alice Pleasance Liddell, was born. She went on a Grand Tour of Europe, and either she or her sister Edith seems to have been for a while the love interest

of Prince Leopold, the youngest son of Queen Victoria (When Edith died, the Prince was one of the pall-bearers).

None of this makes Alice more famous than her father. She is more famous because she is *the* Alice. She is *Alice in Wonderland* (or rather, *Alice's Adventures Under Ground*, as Charles Dodgson – who wrote as Lewis Carroll – entitled his original manuscript). Dodgson was a family friend, and during one trip on the river in Oxford, Alice asked him to entertain her. He told her a story about herself, as he often told stories for the Liddell sisters, but this one he finally wrote down.

Impressionable young lecturers in Christ Church are told that the steep, stone spiral stairs at the back of the hall are the rabbit hole that Alice falls down to begin her adventure. In view of the eccentric, aristocratic world of 19th-century Oxford, I hope so.

After the death of Henry Liddell, Thomas Hardy wrote:

LIDDELL AND SCOTT
ON THE COMPLETION OF THEIR LEXICON

'Well, though it seems
Beyond our dreams,'
Said Liddell to Scott,
'We've really got
To the very end,
All inked and penned
Blotless and fair
Without turning a hair,

This sultry summer day, A.D.
Eighteen hundred and forty-three.

 'I've often, I own,
 Belched many a moan
 At undertaking it,
 And dreamt forsaking it.
 – Yes, on to Pi,
 When the end loomed nigh,
 And friends said
 'You've as good as done,'
 I almost wished we'd not begun.
 Even now, if people only knew
 My sinkings, as we slowly drew
 Along through Kappa, Lambda, Mu,
 They'd be concerned at my misgiving,
 And how I mused on a College living
 Right down to Sigma,
 But feared a stigma
If I succumbed, and left old Donnegan
For weary freshmen's eyes to con again:
And how I often, often wondered
What could have led me to have blundered
So far away from sound theology
To dialects and etymology;
Words, accents not to be breathed by men
Of any country ever again!'

 'My heart most failed,
 Indeed, quite quailed,'
 Said Scott to Liddell,

'Long ere the middle! ...
'Twas one wet dawn
When, slippers on,
And a cold in the head anew,
Gazing at Delta
I turned and felt a
Wish for bed anew,
And to let supersedings
Of Passow's readings
In dialects go.
'That German has read
More than we!' I said;
Yea, several times did I feel so!
'O that first morning, smiling bland,
With sheets of foolscap, quills in hand,
To write *aaatos* and *aages*
Followed by fifteen hundred pages,
What nerve was ours
So to back our powers,
Assured that we should reach *wwdes*
While there was breath left in our bodies!'
Liddell replied: 'Well, that's past now;
The job's done, thank God, anyhow.'
'And yet it's not,'
Considered Scott,
'For we've to get
Subscribers yet
We must remember;
Yes; by September.'

'O Lord; dismiss that. We'll succeed.
Dinner is my immediate need.
I feel as hollow as a fiddle,
Working so many hours,' said Liddell.
(The original has Greek text, here transliterated)

Lexicógrapher. *n.s.* [lexicon and grapho; *lexicog-raphe*, French.] A writer of dictionaries; a harmless drudge, that busies himself in tracing the original, and detailing the signification of words.

Samuel Johnson's
A Dictionary of the English Language (1755)

Grenfell and Hunt:
finding classics in a rubbish dump

Bernard Pyne Grenfell (1870–1926) and Arthur Surridge Hunt (1871–1934) were in their twenties when they began archaeological excavations in a small Egyptian village called *el-Behnesa*, about 100 miles south of Cairo. Its ancient name was *Oxyrhynchus*, 'City of the Sharp-Nosed Fish', after the Nile fish that was taken to be a god by the people who first lived there.

Grenfell and Hunt had met when Classics students at The Queen's College, Oxford. At this time, everything to do with Egypt was all the rage. In 1878, Cleopatra's Needle, an obelisk given to the British by the Turkish viceroy to Egypt, made it to the Victoria Embankment in London. All kinds of curiosities, including scarab beetles, book rolls and

mummies, were being trafficked for those who were wealthy and interested enough. The more daring even travelled to Egypt themselves.

This interest was focused on the Egypt of the pharaohs. However, there were, of course, many different aspects to Egypt's past, and the little-regarded village of el-Behnesa was about to reveal some of the most remarkable classical discoveries of all time.

El-Behnesa was not an imposing place. There were no great classical buildings to be uncovered: in fact, only one classical column remained, as the walls had been plundered for their building stone. It was not the discovery of gold, statues or vases that made this place remarkable. It was its rubbish dumps.

Low hills turned out to be rubbish dumps for ancient books and documents. Accidental discoveries by farmers were the initial trigger. They were digging out fertile earth called *sebbakh* from the dumps, and undoubtedly destroying now completely lost texts in the process. The dry climatic conditions of that part of Egypt meant that texts could be preserved in the sand, unlike in the moist, temperate climates of Greece and Italy. Clearly, someone recognised their value, and various texts, perhaps from Oxyrhynchus, came onto the antiquities market. Some hugely important works were purchased by the British Museum, including Aristotle's *Athenian Constitution* and the *Odes* of the poet Bacchylides. Before this, these books had been known only from passing references and quotations in other authors' works.

Grenfell and Hunt — under the aegis of the Egypt

Exploration Society (EES), still going strong today – set out to find lost works. They chose Oxyrhynchus as it had been a flourishing medieval city with its own bishop, 30 churches and tens of thousands of monks and nuns. They were hoping to find lost biblical and Christian texts, as well as classical works.

Grenfell and Hunt lived lives of extreme physical and mental stress digging in Egypt. They were there for many 'seasons': the period from late autumn/early winter to spring when the weather was bearable and the Egyptians could spare time from their fields to work in the trenches that they dug for £30 a week – that paid for the whole group of about 100 men and boys. There was an extra payment, *bakhshish*, for every papyrus found, to try to stop papyri being stolen and sold to dealers.

The breakthrough day was 11 January 1897. That day they found a papyrus of the 'saying of Jesus' and a section of the Gospel of St Matthew. Within only three months of digging the rubbish dumps, they had filled 280 boxes with fragments of papyri.

Papyrus was the ancient form of paper (see p. 43 for an image of a papyrus of Euclid). Whereas paper is made from pulped trees, papyrus plants grow in the watery areas of Egypt and are incredibly fibrous. The sheets of papyrus that were, and still are, written on are generally made in the following way. The huge, reed-like papyrus plant is cut down and its stem is sliced into thin strips. One set of strips is set out horizontally. On top of that set is placed another, vertical set, in order to make a mesh. They are

then pressed together, and dried. The natural glueyness of the papyrus reed makes the two levels stick together. Thus, there are two sides to a piece of papyrus that is to be used for writing. There is one side where the fibres run horizontally, rather like a ruled schoolbook. This is the *recto*, the 'right' side. There is another where the fibres run vertically. That is the *verso*, the back.

Then, of course, you have to keep those sheets together. Ancient books were not actually 'books'. Books as we recognise them with pages bound in a spine began with the *codex* (pl. *codices*), which developed from Roman writing tablets that were held together by leather straps that ran through drilled holes. A codex was generally a set of vellum or parchment sheets bound in a book-like format. Mostly, Grenfell and Hunt found sections of book rolls. Book rolls used two wooden pins to store a long papyrus sheet (in fact, a series of papyrus sheets fused together), and the sheet was rolled from one pin to another as the roll was read. Of course, the codex won over the book roll, as that was a far more convenient way to read (imagine checking a reference in a series of rolls ...).

Grenfell and Hunt seemed to find new texts every day. The next issue was how to get them home. They sent one roll back to Britain in a Huntley and Palmer's biscuit tin. In the end they had metal tins made from old kerosene canisters on an almost industrial scale – 700 by the time their excavations were finished – to send pieces of papyri back (the papyri had generally been torn up before they were thrown away). While they dug in Egypt in the winters,

they worked on the papyri in Oxford in the summers and eventually published sixteen volumes of the texts that they had found.

Sometimes, Grenfell and Hunt found a most extraordinary cluster of papyri in the dumps. One night, it grew too dark to extricate all that was there safely. Guards were posted, and the rest taken out the next day. They found works of the philosopher Plato, the historian Thucydides, the poet Pindar. There were literary fragments of unknown authors. There was also the kind of stuff we might now put through a shredder – tax returns, accounts of farm animals, medical prescriptions and love letters – and the common stuff – magical spells and incantations.

Most of it was written in Greek, some in Coptic (a form of Egyptian) or Demotic (another form of Egyptian). Rarely, there were hieroglyphs. Extremely rarely, Latin.

Grenfell's working life ended in 1920 when he suffered his third nervous breakdown. New papyrological discoveries still make it to the papers when, for instance, they turn out to be another longed-for poem by Sappho (p. 203). But Grenfell and Hunt had been pioneers of an entire discipline and, even with huge advances in technology, the way of reading and interpreting papyri is still, essentially, theirs.

> **vellum.** n.s. [*vellin*, Fr.; *velamen*, Latin; rather *vitulinum*, low Latin.]
> The skin of a calf dressed for the writer.
> Samuel Johnson's
> *A Dictionary of the English Language* (1755)

How to read a papyrus

This is not a job for the uninitiated. To do it, you need a series of skills that do not come together very often in one individual. You need a solid grasp of the ancient languages you are trying to read. You need to have studied palaeography – what ancient writing is actually like. And you need to be well-versed in the author you are reading or the kind of document you are looking at (such as tax returns, letters, and so on).

There are also two basic types of writing. There are book hands, those used generally for literary texts, which use clear and separate capitals, and the documentary hands, those used for documents, which use cursive script. Even the book hands are not the easiest to read, as ancient texts did not put spaces between words, but wrote continuously, in *scriptio continua*:

SOTHETEXTYOUAREREADINGWOULDHAVELOOKEDLIKETHIS

In fact, this is not as difficult to get used to as it seems at first. Trickier are the cursive scripts used for documents. Literary texts were prized and expensive, which is why they could be incredibly beautiful and laboriously written. A record of the number of cows you had was a practical document that you would spend only the minimum time on creating, so these were written in cursive, documentary hands. Basically, they are a kind of joined-up writing in Greek that only the very experienced can read accurately.

Of course, when you dig sections of text out of the earth, very few fragments are in any way complete. There are gaps, worm holes, rips and all types of damage. This means that you have to try to restore the gaps to make sense of the piece. So the line above might have looked like this:

·O··TEX··OU·R·E··ING··ULDHAVEL····L·ET··S

In publications, dots are used like this to mark out the number of missing letters from the space available in the papyrus. If that is so, you can see that there are arguments to be had. Did it say 'would' or 'could'? Sometimes you have other factors to help you, such as metre in poetry or standard wording in documents. Sometimes you will never know for sure.

There are times when the letters lost are not lost completely, and science can come to our rescue. This is no clearer than with the Herculaneum papyri, found in a Roman villa that had been covered with ash from the eruption of Mount Vesuvius in AD 79.

The Villa dei Papyri

The Villa of the Papyri was buried in its entirety due to the eruption of Mount Vesuvius in AD 79, as was neighbouring Pompeii, capturing a moment in time. Book rolls were found scattered on the floor, presumably as those trying to flee took some of their treasured possessions with them.

Excavations there began in the 1750s, and at first it was thought that a library had been found that would yield the literary works that were eventually to be uncovered at Oxyrhynchus.

In fact, it turned out to be a personal library, probably that of the Roman noble family, the Pisones. The Pisones had been patrons of the Epicurean philosopher Philodemus of Gadara; the library housed many of his works.

This library survived because the heat of the falling ash carbonised the complete book rolls. They were charred, so the ink and the papyrus were both black, but most importantly, the ash had sealed them off from any damp.

Reading these papyri is incredibly challenging. Unrolling them is the first problem, as the papyri are extremely brittle and can turn to dust in the attempt to peel layer from layer. Grenfell and Hunt had had to 'relax' the screwed up papyri they found in the rubbish dumps; this could be done, as Hunt describes, with damp old washcloths, some brushes, a blunt penknife and human fingers. Basically, the dirt was brushed off and then the papyrus was made only a little damp between the washcloths so that it could be smoothed and flattened. No such methods could work with the brittle Herculaneum rolls. The earliest attempts to get at the papyri involved cutting the rolls in half, with the thought that the sections peeled away could be put back in order later. Of course, much was destroyed this way. Rose water, mercury and 'vegetable gas' were also used in efforts to open the book rolls. More were destroyed.

In 1753, help was sent from the Vatican library in the form of Antonio Piaggio. He realised that the roll did not have to be cut crudely all the way through but that, once the outer 'bark' levels had been cut and removed, there was often a core that could be unrolled with more success. He even invented an *unrolling machine* to help with the process. Each time a layer is removed, it is important to record what is seen immediately, as removing that layer again to obtain more text could cause further destruction. Often, fragments have small sections of different layers stuck to them, making reading them even more difficult.

Even when you get at some of a Herculaneum text, you still face black on black. Sometimes, just tilting the papyrus back and forth in the light will let the ink shine against the dull black of the papyrus. It has been said that the best natural light is sunshine on snow. But there are now sophisticated ways of getting more out of the traces by looking through a microscope or using infrared light. Also, ultraviolet light makes clearer the inks used in late antiquity that were metal-based. Photocopies can be helpful, but now the best techniques use digital scans, so that the contrast between the papyrus and the ink can be manipulated on a computer. The use of multi-spectral imaging – a process that was designed originally for the NASA space programme – has revolutionised reading the Herculaneum papyri. It takes multiple images across different wavelengths until the best contrast is obtained. Parts of the papyrus can be magnified and manipulated to get the best possible results.

In 1819, Wordsworth expressed the general desire that more ancient poetry could be found, rather than philosophy:

> O ye, who patiently explore
> The wreck of Herculanean lore
> What rapture! could ye seize
> Some Theban fragment, or unroll
> One precious tender-hearted scroll
> Of pure Simonides.

<div style="text-align: right;">from 'September, 1819'</div>

However, it might be there. There are rooms that have not yet been excavated, and they might include many more texts, including the majority of a Latin library. There would then be the possibility of almost-contemporary texts of poets such as Virgil. Philodemus quoted many lyric poets in his works. Perhaps those books were kept near his own.

antiquity. *n.s.* [*antiquitas*, Lat.]
Old times, time past long ago.

> *I mention Aristotle, Polybius, and Cicero, the greatest philosopher, the most impartial historian, and the most consummate statesman of all antiquity.*

<div style="text-align: right;">Addison, Freeholder, No 51.</div>

Samuel Johnson's *A Dictionary of the English Language* (1755)

Vindolanda: Latin letters in the loo

Vindolanda is found high in the Pennine Hills, about 25 miles from the city of Carlisle in the North of England, just at the point where the country is at its narrowest. It is a mile south of Hadrian's Wall. It was not completely cut off, as there is evidence that the women there had the same fashions in shoes as the rest of the empire and you could travel to London in about a week. It was the site of a garrison of about 50,000 men and was at the frontier of the Roman Empire: its job was to hold the line.

What is extraordinary about this garrison – for garrisons were found all along the borders of the empire – is a remarkable archaeological find, now repeated in Carlisle and Caerleon in Wales. Small, thin strips of wood, about the size of a postcard, have been found preserved there, and so has the Latin writing on them, as they were often folded in half like a greetings card, with the text on the inside.

The fact that they still exist is amazing. Papyri (p. 131) were found in the Egyptian desert because of the dry conditions, but why didn't the Vindolanda Tablets rot? Some were found in the remains of buildings, some in ditches, and some partially burnt. They are clearly fragmentary. It seems that they were preserved due to the kind of damp, anaerobic conditions that also preserved Lindow man (the body in the bog) who can still be viewed, alongside the tablets, in the British Museum. These conditions explain why the site also preserves Roman leather shoes and wooden combs, for instance. Where were these conditions found

that stopped these tablets from rotting? Well, they seem to have been stuffed into an area used as a toilet! Nice.

While they cannot give us a complete picture, the tablets provide a series of 'through the keyhole' peeks into what life would have been like for the inhabitants of Vindolanda.

The tablets give us two basic kinds of text: some are documents that talk about the strength of the army stationed there, or its activities, or the amount of food needed. There is talk of tradesmen, bathmen, brewers and slaves. Then there are personal documents, especially letters. The most prominent writers and recipients of the found letters are Flavius Cerialis, the prefect of the Ninth Cohort of Batavians (Germans from the Rhine Delta), and his wife, Sulpicia Lepidina; they date from c. AD 97–102/3. Cerialis wrote to people who knew the governor of the country, who was just a step away from the emperor. Just like today, powerful people – and those who wanted to be more powerful – invited other powerful people to dinner. The Vindolanda Tablets include dinner invitations.

But life wasn't all about the army. There is a letter written to Sulpicia Lepidina from Claudia Severa, inviting her to a birthday party. The letters written by the women in Vindolanda are the earliest known pieces of Latin written by women that survive. Here is the invitation (Tablet 291):

Claudia Severa to her Lepidina greetings. On 11 September, sister, for the day of the celebration of my birthday, I give you a warm invitation to make sure that you come to us, to make the day more enjoyable

for me by your arrival, if you are present (?). Give my greetings to your Cerialis. My Aelius and my little son send him (?) their greetings. (2nd hand) I shall expect you, sister. Farewell, sister, my dearest soul, as I hope to prosper, and hail. (Back, 1st hand) To Sulpicia Lepidina, wife of Cerialis, from Severa.

A. Bowman & D. Thomas, *The Vindolanda Writing Tablets*. Publication Number 291. (1994)

Cerialis also found time for some fun. Tablet 233 is a draft of a letter to Brocchus about going hunting. It is from a tablet that was re-used after having a list of food on it:

gruel ...
pork-crackling ...
trotters ...
Flavius Cerialis to his Brocchus, greetings. If you love me, brother, I ask that you send me some hunting-nets (?) ... you should repair (?) the pieces very strongly.

Ibid. Publication Number 233.

The Tablets show us how little we know about the extent of early literacy. In the chequered history of women's education, it may come as a surprise that at least the wives of senior army officers could write, and well too. Of course, we cannot generalise from the snapshots that we have here about literacy or birthday parties, but they are visions of an extraordinary personal history.

The first public library

It seems clear that the earliest libraries were private ones, built up by and for individuals.

In ancient Mesopotamia (basically modern Iran and Iraq) writing first came about just before 3,000 BC by inscribing small marks that look like little chicken feet onto clay tablets, called cuneiform. We have lots of these tablets. If a fire broke out in ancient Greece or Rome, all the papyri would be lost, but if a temple or palace were burnt in Mesopotamia, the clay would be baked hard and preserved.

The first impetus towards writing was commerce: the recording of commodities, such as grain, animals and other resources. As time went on, this developed into logging marriage contracts, business contracts, loans and anything else you wanted a record of in case of a dispute. Naturally, the list of subjects that were preserved developed, including accounts of myths and religious subjects.

The last significant ruler of the Assyrian Kingdom, Ashurbanipal, ruled for nearly 50 years (668–627 BC). He is the first person we are absolutely certain founded a library, with his name written on the backs of the tablets. He himself claims that he was the first king to be literate. From his library come texts of the epics of Creation and Gilgamesh, as well as most of the literature we have of the ancient Near East.

In ancient Greece, the geographer Strabo tells us that Aristotle was the first to collect books, and he is even said to have taught the kings of Egypt how to arrange a library.

Aristotle's books were used by him in his philosophical and scientific enquiries: it was a personal library. If a collection is big enough, it needs to have a system of organisation, of cataloguing, to be truly useful. It is almost certainly such a method that Aristotle taught the Ptolemies in Egypt when they did something rather remarkable: they set up the first public library in Alexandria sometime around 300 BC.

The Ptolemies had won Egypt, the richest part of the old empire of Alexander the Great, when it was torn into three after his death (see p. 30). The first four ruling Ptolemies were intellectuals and scholars in their own right and clearly wanted to make their new capital, the city of Alexandria, the cultural capital of the world. The leading mathematicians, philosophers, geographers and medics were all drawn to the city by the sponsorship and wealth of the Ptolemies. There was also the priceless resource of the book collections they amassed that formed the basis of the libraries they founded.

The Ptolemies were ruthless in acquiring books. They sent agents all over the Greek world to buy whatever they could. They preferred older books. As books were reproduced by being copied by a scribe, the thought was that the older the book, the fewer copyings it had gone through, and so the fewer errors it would contain. It seems that they were so intent on this that a new market arose in forging 'old' books. They also commandeered any books found on the ships that docked at Alexandria. Since the Ptolemies had a vast number of scribes, they would have the book copied, keep the old copy and give the new one back to the owners. They decided to include anything and everything.

But it didn't matter how many brilliant works there were if they couldn't be found. So, a director of the library was appointed who was responsible for its organisation. He would have been an intellectual and would often have worked as the tutor of the Ptolemies' children. Zenodotos was the first, presumably re-working the insights of Aristotle to suit the library. It seems that he was responsible for organising the library by means of an alphabetical order, after writing a glossary of rare words using that order, although only by initial letters. A book's author and perhaps a word or two about its contents were written on a tab that looked a bit like a gift tag and tied to the end of the roll. It took about another 500 years for full alphabetisation to be employed.

Callimachus of Cyrene in Libya, (c. 310–240 BC), was one of the foremost intellectuals of his age and worked in the library, but was never one of its directors. He wrote the painstaking *Pinakes*, or *Tables*. They covered 120 books and were a detailed record of Greek writings that seem to have grown out of the cataloguing work necessary to find the books on the shelves. Each entry discussed the areas on which the author wrote and a list of their works. However, this was not Callimachus' only achievement. He wrote poetry of immense subtlety and learning, and criticised old-fashioned epics, claiming 'a big book is a big evil'.

Eratosthenes was the director from about 245–205 BC. He was another towering intellectual, in geography and astronomy, and managed to work out the circumference of the Earth to a remarkable degree of accuracy, with an error of only 1.6 to 16.3 per cent, depending on which unit of

measurement he is taken to have used. He could learn about the world from the library by consulting the reports of the Ptolemies on their expeditions as far away as Somalia to hunt for elephants, and from the accounts of the journeys of Alexander the Great as far as India (p. 30).

Directors of the library wrote glossaries, grammars and commentaries. They established sound, and, so, canonical, versions of texts that have been copied over and over again, especially of the Tragedians and Homer.

So, where are all these texts now? They were all destroyed, probably by fire, but it is unclear precisely when. The historian and biographer Plutarch claims it was in 48 BC following the civil war between Caesar and Pompey, when Caesar became entranced by Cleopatra and anti-Roman violence erupted in Alexandria. Caesar barricaded himself in the area of the library, keeping the mob at bay by lighting fires. Either the library was burnt down then, or just the books in the storehouses were lost. It seems that something did remain: the Emperor Claudius (AD 41–54) is said to have built an extension to the library. At any rate, we did, in the end, lose the lot. At some time around AD 270, the Emperor Aurelian put down a revolt. The palace area, which had included the library, was completely laid to waste.

apócrypha. *n.s.* [from *apokrupto*, to put out of sight.]
Books whose authors are not known. It is used for the books appended to the sacred writings, which, being of doubtful authors, are less regarded.
Samuel Johnson's *A Dictionary of the English Language* (1755)

The Rosetta Stone: a battle for decipherment

The most visited exhibit in the British Museum in London is, at first sight, a most unprepossessing chipped piece of black granite with the remains of an inscription on it. It is not beautiful, unlike the pieces around the corner in the gallery, where there is some of the most striking Assyrian relief sculpture you could see. It does not tell an interestingly enigmatic story, unlike the sculptures of the Elgin Marbles from Athens (p. 50): in fact, it relates a boring decree about potential tax breaks. The Rosetta Stone, however, is historically priceless – all because Greek was part of the means of unlocking the mystery of Egyptian hieroglyphs.

Three dramas have played out around the Stone. The first was the work of the priests and advisers of the boy pharaoh who orchestrated the decree to try to shore up his fragile hold on power. The second was the imperial battle of the French and British to own it as they fought each other in Egypt. Finally, it was the battleground upon which was fought a ruthless scholarly battle to crack the hieroglyphic code.

The pharaoh, Ptolemy V, came from the dynasty that had taken Egypt on the death of Alexander the Great, founded the great library at Alexandria, and ended with Cleopatra, who charmed both Caesar and Anthony. Ptolemy V came to be god-king in 205 BC when his father died suddenly, his mother was killed and there were riots throughout Egypt. He was six years old. By the time the Rosetta Stone decree

was written in 196 BC, he was in his teens, and his hold on power was still tenuous, despite his lineage. The tax breaks in the decree were the means Ptolemy's advisers employed to keep him, and them, in power.

The second drama really was a battle: in 1798, the French invaded Egypt, as Napoleon wanted to cut off the British trade route to India. In the way that the Nazis took art treasures from all over Europe as different countries came under their control, so Napoleon brought with him a team of scholars to make sure that the finest antiquities were taken back to France. One of these antiquities was the Stone. It was found in the town of Rosetta, *el-Rashid*, although it had originally been set up in the temple at Sais on the Nile Delta, about 40 miles away. It was now intended for Paris. However, Napoleon's defeat in the Battle of the Nile required that antiquities be handed over to the victorious British. Painted on the sides of the stone are 'Captured in Egypt by the British Army in 1801' and 'Presented by King George III'. The Rosetta Stone had been branded as British.

Straight away it was displayed in the British Museum, where it could – and still can – be seen for free. As a result, copies of it spread across the world, and the race to decipher hieroglyphs began. The Rosetta Stone had the potential to unlock hieroglyphs because the inscription on the stone is written in three languages: Greek, Demotic (a common form of Egyptian) and Hieroglyphs. The (correct) assumption behind the story of the Stone is that the three different languages repeat the same information.

The Greek was easy: there were many people who could read that. It seemed that if the Greek could be read, so could the rest. But it was not that easy. Hieroglyphs were the script used by the priesthood when the Rosetta Stone was published, but knowledge of how to read it had died out within a few hundred years of that point. The work had to begin from scratch, with the Greek as only the final check.

Again, this was a contest between the British and the French. The two main scholars who worked on the Stone were the British Thomas Young and the French Jean-François Champollion. The first breakthrough came from the British camp: Young realised that the Demotic and Hieroglyph texts were related linguistically. Perhaps even more importantly, he worked out that the cartouches, the ovals that contain hieroglyphs, contained royal or religious names. It was known from the Greek that this inscription was about Ptolemy. As Ptolemy is not an Egyptian word, Young assumed that somehow his name was written alphabetically. This was a major breakthrough, as it took the leap to understanding that the images used to write hieroglyphs could represent letter sounds. However, at this point, Young got stuck, as he thought only foreign names were spelt out in this way, and that the rest of the hieroglyphs were not alphabetic.

The British won the battle to own the Stone, but the French won the battle to decipher it. The brilliant Champollion realised that hieroglyphs work in two ways: they work as logograms – the picture represents the word

– but they are also phonetic – the hieroglyph represents a sound or syllable within a word throughout the text. Patterns emerged and, through comparisons with other bilingual texts, it became clear that there existed a sophisticated literature behind the hieroglyphs, as well as formulaic priestly pronouncements.

The Rosetta Stone is an extraordinary symbol of how we come to understand the past, and of how our grasp of that past changes and evolves with what we understand and how we interpret that understanding. It shows the power of physically 'owning' the past and the determination that lay behind cracking the code. Being able to read it unlocked an entire written culture for us. It is rightly the most visited object in the museum.

Modern uses of Latin

Caput Primum
PUER QUI VIXIT

Dominus et Domina Dursley, qui vivebant in aedibus Gestationis Ligustrorum numero quattuor signatis, non sine superbia dicebant se ratione ordinaria vivendi uti neque se paenitere illius rationis. In toto orbe terrarium vix credas quemquam esse minus deditum rebus novis et arcanis, quid ineptias tales omnino spernebant.

Harrius Potter et Philosophi Lapis

Some useful Latin

O tempora, O mores!
The times! The morals! (Cicero)

Quantum materiae materietur marmota monax si marmota monax materiam possit materiari?
How much wood would a woodchuck chuck if a woodchuck could chuck wood?

Mellita, domi adsum.
Honey, I'm home.

Semper idem
Always the same thing (Cicero)

Carpe Diem!
Seize the day! (Horace)

Monstra mibi pecuniam!
Show me the money!

Semper inops quicumque cupit.
Whoever desires is always poor. (Claudian)

Clamo, clamatis, omnes clamamus pro glace lactis.
I scream, you scream, we all scream for ice cream.

Timendi causa est nescire.
Ignorance is the cause of fear. (Seneca)

Si vis pacem, para bellum.
If you want peace, prepare for war. (Vegetius)

Modern Latin abbreviations

AD	*anno Domini*	in the year of the Lord
a.m.	*ante meridiem*	before midday
c.	*circa*	about, approximately
cf.	*confer*	literally, *bring together*, so 'compare'
cp.	*compare*	compare
CV	*curriculum vitae*	course of life
et al.	*et alia*	and other things
etc.	*et cetera*	and the others
e.g.	*exempli gratia*	for example
fl.	*floruit*	he/she flourished, was in the prime of life
f. (singular)	*folio*	and following (one page)
ff. (plural)	*foliis*	and following (more than one page)
ibid.	*ibidem*	in the same place (reference)
id.	*idem*	the same
i.e.	*id est*	that is

n.b.	*nota bene*	note well
nem. con.	*nemine contradicente*	with no one speaking against it
op. cit.	*opera citato*	the work cited
p.m.	*post meridiem*	after midday
pro tem.	*pro tempore*	for the time being
P.S.	*post scriptum*	after what has been written
Q.E.D.	*quod erat demonstrandum*	that which had to be demonstrated
Re	in *re*	in the matter concerning …
R.I.P.	*requiescat in pace*	may s/he rest in peace
sic	*sic*	thus/in that way it was written

NOW FOR A SHORT WRITTEN TEST ...

❖ Why is the 'alphabet' so called?

❖ What, apart from the obvious, did the Romans do at public toilets?

❖ Who said '*et tu, Brute*'?

HEAPS, TRIANGLES AND OTHER PHILOSOPHICAL QUANDARIES

Here we have some questions and problems about life, the universe and everything that really matters. As you will see from what comes next, nothing is certain. Nothing at all. There are, perhaps, a very few postulates about the point and the line that cannot really be argued about, but, after that, pretty much everything is up for grabs. When or if we find the answer to this stuff, the universe is ours. That is probably why we won't. Try to find some answers for yourself. In the end, trying to find out is all I think really matters.

Atoms and void

I think one of the greatest intellectual achievements must be that of Democritus and his mentor, Leucippus, who lived in Greece in the 5th century BC. They came up with the key idea of physics – that our universe is made up of atoms and void. They could rely on nothing like the science or mathematics that we have at our disposal today. They got there simply by thinking about it.

Their stunning work, like almost all such leaps forward,

relied on reading the works of thinkers who had struggled with similar problems. In particular, there was the work of Parmenides, which we now have only in fragments as sections of text copied or paraphrased in the works of others.

Parmenides set out two arguments: 'The Way of Truth' and 'The Way of Opinion'. 'The Way of Truth' clearly aims to tell us how reality is. Reality, he claims, is unchanging and perfect. As such, how could reality have a beginning or an end? Parmenides' claim is that reality could never not-be, nor could it perish, as he considers it impossible that 'what-is', as he calls it, could ever come from 'what-is-not'. This is because that would fail the test of the 'Principle of Sufficient Reason': for something to come to be, there has to be a 'need' for it to develop. But what need could there possibly be in what-is-not? This is the problem I've always had with the Big Bang Theory, and I've never had an answer that makes sense.

However, Parmenides' 'what-is' is very difficult to pin down. Sometimes it seems that he uses 'what-is' to talk about reality; sometimes it is clearly used to discuss spatial dimensions. At other points in the fragments, 'what-is' and 'what-is-not' appear to be used to work out the logical parameters of the language he employs. Parmenides talks of these parameters as a 'well-rounded sphere'. This might be a metaphor for what he considers a perfect argument, or it might be about space, that reality is a perfect unchanging sphere.

If that is the case, Parmenides has deliberately cut himself off from explaining the phenomena we wrestle with:

what is change, or growth? Or death? What is the nature of the stars and planets? What is everything made of? How do we perceive things? It seems that a second-best theory was set out in the Way of Mortal Opinions. The point was that we still need some grasp on these issues, some way of understanding change and diversity, but Parmenides could not get to an answer to these problems with only the duality of is and is-not, so he had to introduce further principles that did not fit with the Way of Truth. He did this in The Way of Opinion. The discussions there are only opinions, not Truth, but they give us something to go on. The problem was, of course, that the two ways could not be reconciled.

This is where the atomists, who are also preserved only as fragments, come back in. The idea of the single, unchangeable sphere of truth is very attractive. You hold on to the metaphorical notion of perfection, but you also retain the spatial notion of the perfect ball of matter. Unlike Parmenides' idea of a perfect 'one', they set up the idea that there were billions of 'ones', maybe an infinite number. These 'ones' could then combine in different configurations and separate again, in this way explaining change and diversity. The *atom* means 'the uncuttable' in Greek. The universe, the atomists claimed, was made up of perfect, uncuttable, Parmenidean-style ones, but, nevertheless, with different shapes and sizes. This would explain why some atoms were more likely to hang onto other atoms – Democritus claimed some even had hooks – thus making a substance more difficult to destroy.

Of course, for such combinations to happen, the ones cannot be crammed together with no ability to move around. They need some room. This is the void. The atomists set out 'the thing' and 'the nothing'. In 'the nothing', the atoms, 'the things', had the space to move and thus to create, or destroy, combinations with other atoms.

Now it seems that we have two things, and so we violate the Parmenidean principle of the one, as we have atoms *and* void. It is clearly possible to argue this point, as Aristotle does, by stating that having atoms and void makes what-is-not exist just as much as what-is. But it seems that Democritus at least thought that this issue of the existence of the non-existent could be avoided by considering the void to be the opposite of matter, with no other existence than being that in which the atoms move.

Another principle from Parmenides comes into play when we look at the motion of the atoms: they must always have existed and must always have been in motion. The Principle of Sufficient Reason makes it clear that there is no reason why the whole game would ever have started. Their motion is mechanistic, rather like hitting billiard balls. Once you have hit one ball into another, it is precisely predictable where that second ball will go. If that second ball hits a third, the motion of that third is predictable too.

Once we accept this picture of atoms and void, we have to recognise that we are in a deterministic world. Every atom crash into every other atom would be predictable, if we had enough information. For every cause, the effect is necessary.

There is a huge ethical consequence for this argument: if everything is only made up of atoms that move in precisely determined ways in the void, then, when we make a decision, that decision-making process and the outcome of the decision are merely the playing out of the crashes and motions of atoms. There is the phenomenon of decision-making, but that we have the ability to choose or manipulate the future is an illusion. Whether we are good or bad people is not up to us, nor are our actions. We end up with an empty, purposeless world where murderers have no choice but to be murderers and saints to be saints.

Lucretius on the ethical swerve

Lucretius (c. 99–35 BC) was a Roman atomist who wrote his philosophy in verse, just as Parmenides had done. (Democritus and Leucippus had the sense to use prose, so they could say exactly what they wanted without worrying about poetic metre.) There had been other atomists after Democritus, the most significant of whom, for our purposes, was Epicurus, another Greek. Epicureanism had a tight hold on some of the great and the good in Rome: adherents included Atticus (the orator Cicero's friend) and Cassius (one of the assassins of Julius Caesar). As so many Epicurean writings are lost, Lucretius is one of our major sources for understanding their theories, although he clearly departs from Epicurus' own line in places. The arch-rivals of the Epicureans were the Stoics (p. 191).

Lucretius realised the problem with Democritean determinism: why on earth would anyone even try to lead a moral life if, in fact, what we are is what we are? A determinist theory is a licence to say, 'But how could I help it?' following any crime or indulgence. Because if everything is already mapped out, how *could* you help it? Lucretius wanted to bring back choice for real and the claim that we are responsible for the outcomes of our choices. To do this, Lucretius brought in the *clinamen*, the 'swerve'.

So, all the atoms are colliding in the void, hitting each other in the predictable ways that Democritus discussed. Well, what if, every now and then, an atom doesn't do what you thought it would do? What if it doesn't hit the atom it is meant to, but swerves round it? This is what Lucretius discusses in Book Two of his work *On the Nature of the Universe*. This swerve is the gap in the relentless atom crashes of a deterministic world that gives us back free will and the reality of choice. It is the space within which our decisions can be made by us. As Lucretius said, this is 'so that cause should not follow cause from infinity' (2.255). Of course, the swerve comes at the expense of the purity of what Democritus had to say about a mechanistic universe. The difficulty of Democritus' universe is that it is not somewhere we would want to live.

Lucretius' universe gives us the chance of being autonomous. It allows us the room to think. We would prefer to live here. But just because we would like it to be like this, is it? Who is right? It is interesting that the element of randomness, as well as complete predictability, are being

studied and mapped by modern physicists. We still don't know yet if Lucretius or Democritus is right.

The Euthyphro dilemma

The *Euthyphro* is a dialogue written by Plato after 399 BC. The conversation Plato sets out takes place between his former tutor, Socrates, and Euthyphro, a self-proclaimed religious expert. As Socrates is about to go on trial for impiety, he says how keen he would be to learn what piety or holiness is. He is even more keen to learn from Euthyphro because Euthyphro is confident enough to be prosecuting his own father for murder.

Euthyphro's father had left a worker of his bound and gagged in a ditch while he waited to hear from religious advisers what should be done with him, as the worker had killed a slave. While he waited for a reply, the worker died. Socrates is amazed that Euthyphro can recognise the underlying nature of the situation so clearly, even when it is so complicated. As a result, so-called 'Socratic irony' comes into play here as Socrates is so keen to hear from such an 'expert'.

Of course, Socrates is going to play the same game that he does in all the early dialogues: he is going to lead his interlocutor to contradict himself to the point that he can argue no more. The interlocutor reaches a state of *aporia*: the Greek word means that there is 'no way through' the confusion that he is now in.

However, it is a really interesting point about definition that I want to focus on, rather than Socrates' style of argument. Throughout the conversation, Euthyphro tries to define the 'pious' or the 'holy'. The point is introduced nicely by Socrates himself. If we were arguing about numbers, then we would resort to mathematics; if we were arguing about lengths, we would start measuring. These are easy examples of problems we can solve because there is a factual answer and a recognised means of reaching it, such as using a ruler.

However, when we are talking about the pious or the holy or the good, there is no recognised means of finding out an answer. Questions of religion or ethics cannot be answered with a fact that can be reached by a single, totally reliable, repeatable means that everyone agrees on. In fact, these arguments come down to the fundamentals upon which different theories or arguments are based. If everyone could agree on the fundamentals, then tweaking the rest of the argument would not be that difficult, and a general consensus could be reached. However, if, for instance, one person thinks that the 'good' consists of happiness, and another thinks it consists of doing your duty at all costs, it does not matter how many times you go over it, you are never going to agree completely.

This is one of the traps that Euthyphro falls into: he wants to say that the holy is what the gods love. Unfortunately, the pantheon of Olympian gods were known for their constant quarrelling and fighting, so Euthyphro has no grasp on a fundamental principle here:

one set of gods will think that one thing is holy, and the others will disagree.

A further move that Socrates suggests they should examine is that the holy is what is loved by *all* the gods. Now, is the holy loved by all the gods because it is holy, or is it because it is loved by all the gods that it is holy? What is it that constitutes our fundamental principle: is it something about the nature of holiness itself, or is it the fact that all the gods love it? The fact that all the gods love it does not seem a very good reason for caring about the holy, let alone using it as the basis for prosecuting your own father. So, again, we need to find out the fundamental nature of the holy.

The mistake that Euthyphro makes here is that he can't quite grasp that the two claims he is making are not the same. The two are:

1. Because all the gods love it, it is holy.
2. Because it is holy, all the gods love it.

To give Euthyphro his due, to spot that these two claims are different is very difficult. The reason is that we have a double problem: we don't know what the gods all love, and we don't know what holiness is either. We are trying to define one term by means of another term that we also don't know.

This example might make things a little clearer:

1. Because it is bad, it is against the law.
2. Because it is against the law, it is bad.

We can actually work out that these two claims are not the same. Let's begin with the first claim. Think of something that is against the law *because it is bad.* The kinds of answer you might come up with include murder, burglary, grievous bodily harm, and so on. There clearly is a long list of things that are against the law due to the very claim that they are bad. In this way, we are stating that the ethical badness of murder, etc., is what makes them unlawful.

Now, try to think of an example that fits the second claim. What you need is an example that is bad due only to the fact that it is against the law. It is incredibly difficult to find an example of this. You might come up with something like not paying your taxes as an example of something that is merely unlawful, and that alone makes it bad. But there is an argument against this: if you don't pay your taxes, that means that there is no money for schools and hospitals, and so on. The point here is that we are looking for an example which has no underlying ethical badness included in it. Just being against the law is all that is required. The kind of example that is needed is something like this: in the UK we drive on the left, but in France everyone drives on the right. There is nothing ethically wrong with a country choosing either side (of course, there *is* something very ethically wrong with just swapping sides to the right when everyone else is on the left, as there is bound to be a car crash that way). When driving we all just need to stick to the same side. That a country chooses the right hand side as opposed to the left does not make it a morally *bad* choice. It is no different to choosing to walk on one side of the pavement or the other.

Poor Euthyphro didn't really stand a chance with his parallel claims. We can learn one more thing from our parallel statements. We know what 'against the law' means. Because of that, we can examine the nature of *bad* in each of the statements. There were plenty of examples that fitted the first, and it was really difficult to find one that fitted the second. No example fits both one and two. The reason for this is that we have two completely different notions of *bad* in play. The first is an ethical, moral, notion of bad; the second is some kind of conventional bad that is not tied to morality at all. Because we know nothing concrete about Euthyphro's terms, we can't even work out where the errors are. We are left without a road to journey on, true *aporia*, and Socrates was left with no help before his trial.

Maybe there is irony here. Socrates was fatally poisoned with hemlock by the state for worshipping foreign gods (logic?) and corrupting the youth (there may be a bit more to this charge). He was almost certainly given a harsher sentence because he claimed he had done so much for Athens in his speech in mitigation. He had to drink hemlock and this was described in great detail by his adoring pupil, Plato, who described how the poison started at his feet. In the end, someone who is said to have tried to set out what the ethical life really was had to lie down when his legs felt too heavy as the hemlock moved up his body. When it reached his heart, he died. His brand of holiness was to live the truly good life – the unexamined life was not worth living. If only Euthyphro had had the time to think harder.

Plato's spinning top, or
'Have you stopped beating your wife yet?'

Any investigation, project or philosophical inquiry is highly likely to go wrong if you don't start by asking the right question. How can you even begin if you don't know what it is you are trying to achieve?

Imagine that you're trying to build a table. How can you do that if you don't know what a table looks like or what it is used for? You might be lucky and actually make one despite this ignorance, but think how unlikely that is if you have no idea what you are aiming at and just have a pile of wood and nails. In philosophy, you might be exceptionally lucky and work out which question you should be asking in your project or inquiry as you go along, but usually the whole business is so muddy by then that you just go round in circles.

You might be a little better off than that and have *some* idea of the question you want to answer or the kind of furniture you want to make. But that is still not good enough. If the question is not right, then the answer won't be precisely what you're looking for. Consider this old courtroom anecdote: the prosecutor asks the defendant: 'Have you stopped beating your wife yet?' The poor guy is in trouble whatever he says. If he answers 'Yes', the implication is that he was beating his wife but has now stopped. If he answers 'No', the implication is that he has been beating her and continues to do so. What he really should do is tackle the question and point out that he should be asked,

'Have you ever beaten your wife?' He can then answer 'No' and walk out a free man.

The ancient Greek philosopher Plato (born c. 427 BC) points this out rather brilliantly. He does this by using the idea of opposites. He asks in the *Republic* (c. 436 BC) whether the same thing at the same time and in the same respect can be completely still and also move. The answer is pretty clear: no, it can't. But the underlying problems in most of the questions we ask ourselves and others are not so easy to work out.

Plato asks us to consider a spinning top, the old-fashioned sort, which is basically just a sharpened stick fixed through a patterned circle that you spin with your hand. Think of this top as spinning so that the circumference of the circle is going round and round. But the stick in the middle, the axis for the spin, is not moving at all – it is not wobbling from side to side or inclined in any way. (Of course, the stick will wobble and incline when the spin comes to an end, but think of this perfect spinning moment to understand Plato's point.) So, the questions, 'Have you stopped beating your wife yet?' and 'Is the spinning top moving or not?', make the same point: if you try to answer with a 'Yes' or a 'No', you will give the wrong answer. Rather, you have to answer in a way that acknowledges that the circumference of the circle is moving, but the axis of the stick is not moving at all.

If you don't ask the correct question, if it is not precise enough, then you will get an inaccurate answer, at best.

Why did Plato make such a song and dance about a spinning top? The answer is that he wanted to distinguish between different aspects of the same thing. There is the moving part and the part that is not moving. But this does not make it two different things: there is still only one, whole spinning top.

Desire vs. reason

Plato distinguishes between desire, reason and what he calls 'spirit', which is a kind of righteous anger, the sort of motivation that gets you to rush against the enemy in battle or fight a bully in the playground. This is Plato's famous discussion of the three parts of what he calls the 'soul' or the mind.

As with the spinning top, the parts of the mind are not separable. They are not physical parts: they are different aspects of human motivation. We are still one decision-making person, but sometimes we seem to be 'torn in two'. Imagine being the thirstiest you could possibly be and think about how much you would want, or desire, a drink. There is a drink right in front of you. Your desire or appetite is screaming at you to drink it, but you have been told that it is poisonous. So, your reason tells you not to give in to your appetite for the drink, but to hang on for another one. What is interesting is that your reason cannot remove your appetite – you are still desperate for that drink – but it aims to control it so that you make the 'correct' decision.

This fight between reason and desire or appetite is, for some, a daily battle. I doubt whether there is anyone who has not experienced this struggle at all. It can come in the form of the dieter who eats the cake, the person who knows they drink too much but orders another beer, or the guy who knows he should go home from the office party, but really likes Lucy from Accounts ...

This is the problem of *weakness of will*. It is still discussed in modern philosophy, as well as psychoanalysis. Freud called this conflict of motivations *neurosis*, via his concepts of the *ego*, the *super-ego* and the *id*.

Ultimately, Plato has a very hard-edged answer to this problem. If you *really* knew that you should go home from the party, you would. When you get it wrong, it's because you didn't *really* know at all. And the more you know, the more you will get right.

The problem with this argument is that it doesn't capture the essence of the issue: because you *do* know — in some deep down, slightly drunk way — that you need to go home. But you stay anyway.

It seems that we need to turn to Plato's own philosophical student, Aristotle (384–322 BC), for a more sophisticated response to the problem.

Aristotle's *akrasia*

Akrasia is the Greek term for *weakness of will*. It is a really good place to start, as we don't get confused by asking

whether we have a *will*, what one is, or what is meant by it being *weak*. Rather, *akrasia* means not having power over something, or the strength to win a victory. It is not having the strength to leave the party.

But *why don't we go?* Aristotle has a different answer that uses the notion of logic, a *syllogism* — that is an argument set out in logical form.

A syllogism is actually pretty easy to understand in its basic form. The standard starting point is:

All men are mortal
Socrates is a man

So, Socrates is mortal

There are two premises and one conclusion, and all that is needed is a substitution of one term from the 'All' premise (mortal) and the premise about the individual, Socrates (man), to get us to know something new, that is, that Socrates is mortal. Bingo! Logic and using arguments can teach us a new fact, if only we find the right premises and follow the rules of argumentation.

What on earth has this to do with the party scenario? In fact, Aristotle, in a notoriously difficult section of text, seems to be telling us that, when we are struggling with what to do, we have two syllogisms in play; they are not about learning a new fact, but rather are about which action to take.

They might go a bit like this:

All chances to kiss any pretty girls must
be taken by me
Lucy is a pretty girl

So, Lucy must be kissed by me

All chances to kiss pretty girls other than
my wife must be avoided
Lucy is a pretty girl

But, Lucy must not be kissed by me

The problem is that if you had both syllogisms in your head completely at the same time, then how could you possibly take the wrong action? Of course, this assumes that you are the kind of guy who wants to do the right thing; part of the phenomenon of *akrasia* is that, after you have done the wrong action, you feel regret.

It seems to be crucial that there is one premise that is common to both syllogisms: that Lucy is a pretty girl. The whole problem stems from this fact, and this is the root of the dilemma. There are just two different 'All' premises in play: the one that leads to kissing and the one that does not.

So, how do we understand the problem? Aristotle mentions that drunk people can speak and have no idea what they are talking about, and that people can learn a complex piece of poetry and recite it, but not understand what they are saying. Perhaps our dilemma is a bit like this: when we say that we *know* we should go home, we are like the drunk saying things we don't fully grasp. Again, regret is

important. The next day, we really *do know* that it was the wrong action. What is it that happens in this sobering up? One answer is to think that desire blocks our full comprehension of the conclusion to the correct syllogism. Once we have satisfied that desire, then there is nothing blocking us from the conclusion, from really knowing what the small voice in our head was saying at the time.

What is most interesting is to think about what both Plato and Aristotle are trying to do here. They want us to be fully in control of all our decisions and actions. The Stoics followed this line too, claiming that all *hormai* (n.b. our word 'hormones'), or urges, could be resisted if reason and logic were in complete control. They are looking for us all to be in complete control of our ethical lives. This is partly why this is an issue that stretches into psychoanalysis and psychology: it is accepted by all that there are different motivations, or pulls and pushes, that operate on us, but the extent to which we can master them all is not clear at all.

The lost city of Atlantis and the importance of triangles

The story of the lost city of Atlantis is one that continues to capture the imagination over 2,000 years after the philosopher Plato wrote about it. It is a romantic story of a beautiful island with an advanced culture that got swallowed into the sea, never to be seen again, because it fell out of

favour with the gods. It has been taken up in literature, art and film, even in children's cartoons. Plato wrote about it in the form of an allegory – a story we should use to learn about something that is, perhaps, too difficult to grasp in itself. However, no one can let it go: there have been geological conferences to try to pinpoint its location using satellite images.

It is a bit like Celtic myths: when you see a haze rolling over the sea, you think there just might be something to the 'mist of enchantment' of the Welsh epic poem, the *Mabinogion*, that makes everything (all people, all animals) disappear. Looking at the mist you can, somehow, grasp something, but not completely. It is a way of reaching out to knowledge, yet not being able to put your finger on precisely what it is. Nonetheless, you feel you have got ever so slightly further forward.

And don't we all, secretly, want Atlantis to be real? And discoverable? And still, somehow, a living city?

That is the strange trick of Plato: he wanted reason and knowledge to operate over everything. He wanted logic to explain the world and for us to be perfectly ethical. I'm sure he thought that, with enough work, we could master the underlying mathematics of the universe, which would give us the ability to understand it perfectly. But he also clearly loved a story. He too would have fallen for the mist of enchantment, I am sure.

Atlantis is no different. It is pretty certain that Plato made up the whole thing. But it is not entirely clear what we are meant to learn from it. This is the problem with

not telling it straight: there is room to make up meaning for yourself.

The story of Atlantis is told in two separate dialogues, the *Critias* and the *Timaeus*, which are set dramatically after the discussion of the creation of a perfect society set out in the *Republic*. Through the telling of the story of Atlantis, truth, justice and beauty shine. We do not have explicit, logical arguments. The Atlantis story seems to me a way in which we are meant to reach through the mist and realise that truth, justice and beauty are the guiding principles of the universe, the way the gods actually behave and how human society should function. But we cannot, perhaps yet, perhaps ever, set them out in scientific form.

But setting out the perfect society is not enough if you do not have the ultimate arguments to base it on. If you want to understand the perfect society, don't you need to understand human beings, completely? Don't you also need to understand, completely, the world in which these humans live and work? And what about the world's place in the universe? And how it was made?

Plato was undoubtedly a genius, but a genius without a sense of proportion. Even his great pupil, the philosopher Aristotle, recognised that Plato didn't see that some questions are actually separable from one another. How the creation of the universe relates to me being a good or a bad person might be an interesting point, but it has absolutely nothing to do with whether or not I really am good or bad: that is determined by what I do, what I say and how I treat people, as Aristotle (I think absolutely rightly) claimed.

But Plato was one of those people who wanted it all joined up. He thought that pleasure could not be a process, it had to be a kind of completion. This starts to make no sense at all when you think about processes: surely the pleasure of a good meal is in eating and tasting it, and perhaps even in the preparation and anticipation of it, or looking for the waiter to bring it along. It doesn't seem to me to have anything to do with being full at the end. You could eat more or less anything to feel like that. Is the best bit about sex when it is all over?

But knowledge and perfection were what Plato wanted: being full, not filling up. The only way of really being full was to know it all. That is the problem with the Philosopher King, the guy in charge of the perfect society of the *Republic*: he has to know it all. And who possibly can?

This is why the *Timaeus* is a strange, but beguiling, work. We start with Atlantis and we end up with the basic constituents of the universe.

Plato talks about the *demiurge* in the *Timaeus*: it is a strange word to use in Greek for the creator of the universe. It is not a name for a god, a force or a power; it refers more to the notion of a master craftsman, an artisan. He is the master builder. What he does is even stranger: he basically gets a very large bowl (the receptacle of becoming) and pours triangles into it, which he stirs. Those are the building blocks of everything.

There were four elements that were traditionally taken to make up the substances in the world: earth, air, fire and water. Plato adapts these to fit his theory of triangles, and

different elements take on different three-dimensional shapes. For instance, fire is a tetrahedron and air is an octahedron. The craftsman of the universe makes mathematically understandable three-dimensional elements out of the most basic two-dimensional geometrical figure: the triangle. He then makes them like the atoms of the universe, but they are ones that we can map and fully understand.

In fact, it seems that the receptacle is a neutral substratum, a foundation upon which different elements display their characteristics. This is rather like the philosopher John Locke's (1632–1704) notion of an unobservable substratum in his *Essay Concerning Human Understanding*: it is an unknowable base in which observable qualities inhere. Plato's triangles seem to display their qualities in the receptacle too.

Look how far we have come from a lost city.

But the point of the triangles is precisely that there is a definite, provable and understandable basis to everything in the universe, which itself is seen as a living thing, because to have life is better than to not have life. If we can fully grasp the geometry of the universe, then we can grasp anything on a larger scale, as it has to be made, ultimately, out of these basic figures. Knowledge could be complete and perfect.

But there remains one problem. Why then is our world not perfect, if it is made out of perfect geometry? The answer is that Plato had to reconcile what he wanted with what he saw: there had to be room for the imperfect. As you might have noticed, the world isn't perfect. Plato noticed that too. He could have created the image of a perfect world, but that wouldn't fit with what we actually have.

Back to an old problem: the creator in the *Timaeus* is said to be totally good. However, the universe had some 'non-being' built into it: something that doesn't work with the harmony of geometry. That is ultimately why things go wrong. It doesn't explain why he added that into his theory, but it is a way of acknowledging that not everything in the garden is rosy.

Aristotle rejected the cosmology of the *Timaeus* on two major grounds: the way the demiurge operated necessitated a beginning to the universe and a beginning to time. These are issues that astrophysicists still work on. Ethicists are also still concerned with whether the good is fully obtainable, and even with what 'the good' is. And whether the good is the same thing for a city as for a person. Plato thought that the good of a city was like the good of an individual written in large letters. When it went wrong for Atlantis, the city ended up in the sea because the perfectly rational gods did not like the battle that occurred between the people of Atlantis and the perfectly orderly Athenians. Plato's own Athenians won, but in the old days when they respected truth and discipline.

That again, is the problem of the mist. What Plato wants to indicate, but cannot put into logical language, is difficult to interpret. We don't really know the point behind Atlantis, nor do we really know the point underling the story of the *demiurge* and his triangles. They are both stories that try to grasp what is ungraspable. How much did Plato intend as 'real' and how much is padding? We just don't know.

Good and bad actions

It seems to me incredibly strange that so many actions are judged good and bad purely on outcome. So much in the media is outcome-focused. That, in itself, is not always the wrong way to go: if a brand new hospital is built at huge expense but none of the equipment works and no one can be treated there, that is clearly a bad outcome. But this isn't the kind of thing I mean.

Really, it is about judging human actions. Utilitarians judge human actions on outcome. That means, in its purest form, that whatever I intend when I do something is irrelevant. I could intend to murder someone, but somehow I end up saving someone instead. My action would therefore be good because the outcome was good.

The philosopher Bernard Williams puts this brilliantly in his example known (in a very un-PC manner) as 'Jim and the Indians'. You play the part of Jim, a harmless botanist who is travelling in South America. You stumble upon a small town where the military captain has set up a public execution. There are twenty, randomly-chosen natives who are about to be shot because of a public protest. It is not clear that any of the twenty were actually involved in the protest. However, as a guest, Jim has the option to shoot one, and the other nineteen will be set free. What are you going to do?

I set a version of this problem as an Oxford interview question years ago. I was utterly horrified by the fact that about 90 per cent of candidates said, without the slightest

reflection, 'Shoot one!' So, I changed the question a bit: what if the person were chosen for you, and, unknown to you, your mother was one of the people rounded up and the one you were to shoot, what would you do? The response I still received was: 'Shoot her! I know it is what she would want me to do too ...'

One aspect of this example is skewed. Here we know exactly what the outcome will be: there will be either one dead body on the floor or nineteen. (There will be no daring SAS rescues, you can't shoot the captain instead, etc.) When we bumble along in our everyday lives, is it ever certain what the outcome of our actions will be, apart from the most trivial ones?

One major objection to Utility has been called the 'integrity objection'. The idea is that who you are, the kind of person you are and your fundamental values are being over-ridden by the demands of the outcome. The point is that there are some things you *just wouldn't do. Ever.* Jim might quite reasonably pipe up and say that he is the kind of person who would never intentionally kill anyone, for whatever reason, and certainly not his mother. (This idea cut no ice at all with the 90 per cent.)

However, outcome is important. The fact that someone is murdered or saved is significant, but we need a much more sophisticated theory than Utility can offer. It will become clear that Aristotle knew that too.

The major rival to Utility in modern ethical theory is Kant and Kantian intention- and duty-based ethics. This theory starts from precisely the opposite corner and puts

what you intend in the centre of the ring. If the outcome is good, if you plan for the right thing to happen, then all is well. But if it goes wrong somehow, well, you had good intentions, didn't you?

The notion of duties can end up meaning following rules. St Augustine noticed the trouble with this idea in a little treatise called *On Lying*. You see, he rather got himself into a corner by saying that you should never lie because, in the end, God doesn't like it. Never lie. Then you have the problem of the axe-wielding murderer at the door who is looking for your friend hiding under the kitchen table: can you lie and say you don't know where she is and that he should, perhaps, look outside? Surely saving a life is more important than a little white lie? The problem is that she might have slipped outside while you were chatting to the murderer, and then it will all go wrong *and* you have lied. (Philosophers like extreme examples. Not only do they push a theory to its limits, but they spice up a sedentary life.)

Such basic Kantian ethics doesn't seem to me to capture the complexity of the ethical judgements that we make either.

Aristotle didn't think intention was everything, but he certainly didn't write it off either. In his *Nicomachean Ethics* (a work in almost note form, perhaps lecture notes, said to be written for his son, Nicomachus), Aristotle talks about the intended, the unintended and the not-intended as three different ways of ethically classifying actions. He talks of complex scenarios and times when it is almost impossible to decide what to think. He was also a practical chap, as he

states quite plainly that the criteria we use to make moral judgements are crucial for the legislator.

He also knew that human actions were multi-dimensional things. There is a lot to consider. He knew that actions involved desires and emotions, and they needed to be added into the account, not obliterated (as the Stoics later claimed – p. 191).

One issue Aristotle tackles head on is whether you were forced to take an action: if someone takes my hand and hits you in the face with it, I am clearly not to blame, as I have contributed nothing at all to the action. It could have been a stick, not an arm that hit you. This is a very hard-core notion of force. If I hit you in the face because I was lashing out due to memories of a rubbish childhood, because I was angry or because I had had a bad day, that would not be force at all, by Aristotle's definition. That is all your responsibility. In Aristotle's moral world, you are completely responsible for how you turn out. If you have had a golden childhood, you might well end up a worse person than someone who had a terrible childhood; you might have had a better break and messed it up, but, similarly, from a worse start, you could have pulled yourself up and sorted yourself out.

'Mixed' actions are the tricky ones. Consider a captain pushing his cargo overboard in a terrible storm at sea because that is the only way to save the ship and its passengers. His is a mixed action because no one in their right mind would intentionally throw away their cargo on a beautiful calm day, but it is justified by the circumstances, and

you definitely intend to get rid of the stuff. An example that Aristotle himself says is difficult to classify is the extreme one of a tyrant holding your parents and children; they will be spared if you do something shameful, otherwise they will be put to death. Is your resulting action intended or not?

In Book Three he gives a brilliant account of the ways of classifying actions, and what you make of intention and outcome as determiners of what is good or bad.

You are allowed not to know things. But they have to be particular things, small things, for instance, you didn't know that some water was contaminated. You cannot get away with claiming that you didn't know that murder was bad.

Let's look at when it all goes as planned. You are thirsty, and I want to help you. I get you a drink of water from the tap. There is nothing about the scenario that I don't know. You have a drink, you feel better and I am glad. That is the 'intended'. It is not just about the fact that I want to help, but that I do and then feel good about doing a nice thing. If you are thirsty and I want to kill you, I deliberately give you poison, you die and I'm glad, that is intentional too. It's just bad rather than good. Really, there's nothing controversial there.

Trickier are two cases when things don't go well. Ignorance is involved: I don't know that the water is contaminated and poisonous. But it goes like this: you are thirsty and I want to help (n.b. I want to help at the beginning of both of options). I go to the tap to get the water. I don't know in either case that the water is poisonous.

You die. Well, here the Utilitarian and Kantian stories end. We are back to the tug-of-war of whether we look at outcome or intention. In both cases, my intention is to help with a drink. So is this a good action? In terms of Utility, of outcome, you are dead. Then this is a bad action. So far it seems as though I've only described one case, not two. That is because Aristotle's account is not over yet. We have missed a crucial factor. How do I feel about the fact that you are dead on the floor?

One option is that I'm terribly upset. You were my friend, my noble colleague. I will never get over it. This is a case of the unintended. If I had known about the poison, I would never have given you the water.

There is another option, the masterstroke in Aristotle's account. I wanted to give you a drink for your thirst at the outset, but the fact that you are as dead as a doornail is an utter joy to me. I never liked you. I would never have planned your murder in a pre-meditated way, but it is, nevertheless, just great that you are out of my life. That is the non-intended.

You see, this is the step that Utilitarians and Kant fail to take. In fact, at this point, we are not really judging a single act at all. We are judging a whole person, a character. We need to know what you think about it all afterwards to really say what we think of the morality of the act because we are looking at the morality of *you*.

Nothing has changed. Aristotle thought all of this was important for the legislator. Think about what a criminal trial is like today. We need to establish the facts: did you

or did you not stab him in the back? And did you plan to kill him when you did? That gets us so far, but we care, particularly when it comes to sentencing, whether or not there is any remorse. The judge doesn't sentence the act: he sentences *you*.

Friends: how many kinds are there?

Aristotle, in his *Nicomachean Ethics*, spends more time talking about friendships than anything else. He is the one who said that man is a 'political animal', and that includes all kinds of social interaction. Friends are crucial to the good of *eudaimonia*. He defined that himself as 'living well and doing well'. Even as the consummate scholar, he knew that that study and abstract thought were not all life was about. You had to be able to handle yourself on all kinds of social occasions too.

Aristotle was also a taxonomist, someone who wanted to classify everything and mark the interrelations between different classes. For instance, there is the class of two-footed creatures. This includes chickens as well as humans, but you can separate them by noting that one group has feathers and the other does not.

Aristotle sets out three categories of friends.

One is the 'pleasure' friend. That is why you meet. You might go to the pub together, play golf together or have your nails done together. But it is an arrangement. If you took away the reason why you get together, you wouldn't

bother to meet any more. It doesn't, in itself, stop you being friends, but you really are just friends because you like doing the same thing, and it is nicer to do that with someone to talk to than not.

There is also the 'useful', or the business, friend. Really, there is not much that separates them from the pleasure friend, as you are friends for a purpose. Instead of pleasure, you plan to make money together. That doesn't mean you don't go to the pub or play golf together as well, but it is again aimed a certain goal, and if the goal were removed, then you almost certainly wouldn't bother to meet again. With pleasure or business friends, you don't care about them for who they truly are, but for what you get out of being with them.

Then there is the 'true' friend. There are very few of these in your life and they are incredibly special. Aristotle talks of them as 'another self'. This is a 'complete' or 'perfect' friendship because each person wishes good to the other for their own sake. This kind of love stems from a love of oneself. You have to be equal too in order for it to happen. You can't have this kind of friendship between parents and children, master and slave or – reflecting the world in which he lived – husband and wife because you are not equal. This sort of friendship can also only happen when both people are genuinely good, as based on their characters.

There are many philosophical issues with Aristotle's argument, but here, I think, the broad brush approach captures something incredibly important. This is because it hooks onto the different ways in which we value different

people. And morality is all about values. There are the ones (values, people) we really care about and the ones that we are happy to ditch when something better comes along.

But then Aristotle ratchets it all up a gear. If the true friend, the other self, is the bee's knees, then should we love them more than we love ourselves, or should we love ourselves more? If you need to love the person closest to you, then does that mean you need to love yourself more than anyone else? Or do you love your other self the most? It is the problem of altruism. Is loving another more than yourself real, or is it fake?

Aristotle calls altruism a kind of self-seeking. You are seeking for yourself something of extraordinary value: that which is virtuous and noble, as mirrored in your friend. You might claim that you are looking for the best for the other person and, in so doing, end up with the prize of nobility in turn, but that is not what he means. However, he does talk about noble actions for others in a wider context. You can lay down your life for your friends and your country-men. The whole of the country cannot be your friends, but you can be noble to them all.

Aristotle never really makes it clear who matters more: me or you. But being a good person and realising that it is time to lay down your life for your friends and country are clear. Maybe that is one of the reasons why you need friends. You could be incredibly wise and live in a cave on your own, but you would be lacking something more than having someone to watch a film with over a bottle of wine. You need someone to help you decide when it is time.

There are 'internal' goods and 'external' goods. It is clear that the external ones are, as Aristotle says, good enough looks, a happy healthy family and enough money, for starters. The internal ones are the ones that plug into our characters, who we really are, our fundamental values. And, at that point, friends, the 'greatest of external goods', might be the key. It might be akin to the kind of thing that the philosopher Hume meant by 'sympathy'. We are humans, not gods, however good we are. So when we start to stray a little, the true friend can nudge us back onto the path so that we can continue our great friendship, follow the noble life and continue to work out our place in the universe.

If we *always* act for our own good, how can we have true friends? But also, how can we lay down our lives when the time comes? Aristotle's claim seems to be, in the end, incredibly strong: that the life without friendships cannot be a good life.

The Heap Paradox

Eubulides of Miletus, of the 4th century BC, is known for his paradoxes. He is credited with a version of the liar paradox. He is also known for the 'horns' paradox: you have what you have not lost. You have not lost horns. So, you have horns. You can see the problem: it is obviously nonsense, but the language is compelling.

Perhaps the most important paradox he created is the Heap, the *sorites*, paradox.

Is one grain of sand a heap? No. Are two grains of sand a heap? No. Are three grains of sand a heap? No. Are four grains of sand a heap? No. The point here is that adding one more grain each time (n+1) does not change the answer, as the difference the addition makes is so small it is irrelevant when deciding whether we have a heap or not. We do not make a fuss about such a tiny addition, and so answer 'no'.

But let's keep going, adding one more grain of sand each time. At some point we are going to get to a billion grains of sand. Is that a heap? Yes, that certainly is a heap. The problem we face is that we are forced to say 'no' if we want to keep hold of the notion that adding one is irrelevant. Then we end up saying something we don't mean.

Eubulides also made up the Bald Man paradox. If you are willing to say that a man with one hair on his head is bald, then if he has two hairs on his head, he is also bald. And so on, until you get to the same point: that a man with 20,000 hairs on his head also has to be bald. The Bald Man paradox is not as pure as the Heap, as we can just deny the starting premise that a man with one hair on his head is bald. To be bald means you have no hair at all.

The Heap is so clever because of the vagueness of the term *heap*. There is difficulty in defining what it is. It is just as the United States Supreme Court Justice Potter Stewart famously said about obscenity in *Jacobellis v Ohio* (1964): 'I know it when I see it'. When I see two grains of sand, I do not recognise that as a heap, but I do when I see a billion. That was Justice Potter Stewart's point too, and he said

this when considering pornography in the 1958 French film, *The Lovers*:

> I shall not today attempt further to define the kinds of material I understand to be embraced within that shorthand description ['hard-core pornography']; and perhaps I could never succeed in intelligibly doing so. But I know it when I see it, and the motion picture involved in this case is not that.
>
> *Jacobellis v Ohio* (1964)

The underlying point is that such empirical concepts that come from our experience of the world are tricky to pin down. But are they, in fact, impossible to get at, assuming that we want more precision than the Supreme Court was willing to accept?

It was the Stoics who took this issue to the next level. They were under attack from the Sceptics, who doubted the truth of everything, via the Heap paradox. The Stoics (particularly Chrysippus, who is said to have died in a most unusual way p. 117) were sticklers for logic and wanted every answer to every question to be 'true' or 'false', or, in this case, 'yes' or 'no'. And if, when considering a heap, you end up saying 'no', 'no', 'no', 'no'... 'yes', you are clearly in a lot of logical trouble.

Or are you? There are, in fact two ways to go with this problem: the realist and the anti-realist.

The realists say this: there is a real world out there and it is our job to find it out. As Plato put it, we must 'cut

nature at the joints', that is, we must find out where the joints are in order to understand the world better. There are separations between trees and flowers, between flowers and earth. They are demarcated: it is up to us to find the boundary lines.

The anti-realists say something rather different. They claim that our access to reality is, at best, limited. Whereas realists want to find the joints, for real, in the world, the other camp say that such joints are an illusion. Truth is not out there in the world. Truth is something we construct in our heads: if we think it is a heap, then it is a heap, and there is no possible further test we could apply.

So, what about heaps? Or bald men? Well, it goes like this: if we are realists, then we think that there is an answer to when a heap actually becomes a heap. There really is one grain of sand that pushes the limit, when the n+1 principle no longer applies and we shout: 'That's it, a heap!' If so, we have to accept that it is highly unlikely that we will ever know which grain of sand that is. This is a problem of epistemology, of knowledge. There is a tipping point, but we can't grasp what it is.

The alternative is to claim that it is up to us as individuals to claim when a heap is a heap. There is no external answer, or if there is it is so obscure, it could never be trusted by us, as our senses are so unreliable (for instance, spoons look bent in water, and so on). However, then the rules for truth and falsity, for correctness and wrongness, become so oblique that we don't know where we are any more. Am I right? Are you? Are we all? Does it come down to a vote?

By accepting that there is an answer that we don't know – and probably can't ever know – we accept that there is truth and falsity (a good thing), but we also accept an epistemic (a knowledge) gap where the answer is inaccessible to us. It is, perhaps, possible that this will change with new discoveries about quarks and neurons. But these basic concepts from the world of perception seem open to perpetual debate.

> **pýrrhonism.** *n.s.* [from *Pyrrho*, the founder of the scepticks.]
> Scepticism; universal doubt.
>
> Samuel Johnson's
> *A Dictionary of the English Language* (1755)

You take yourself wherever you go

Lucius Annaeus Seneca (c. 4 BC–AD 65) was a Roman Stoic philosopher and writer. He also had the misfortune to be Nero's tutor. When he got caught up in a conspiracy to assassinate him (he might not have been guilty), Nero forced him to commit suicide.

Before this dismal end, Seneca wrote letters, supposedly to his nephew Lucillius, but they are really open letters to us all. Each one has at least one Stoic theme at its heart. It can be really difficult to get into philosophy: it has a language and technical terms of its own. Seneca realised that you can't start at the serious end of it and expect to understand what is going on. So, the points he wants to make

are usually wrapped up in a story. Some letters have very little story, as they are clearly earmarked for the progressing student of Stoicism, but some are entry level.

One of my favourites is Letter 28, which talks about Lucillius' desire to leave the rat race behind and go on his travels. Seneca begins in a characteristically direct way. He asks if Lucillius thinks he is the only one who has felt like this. And why do long journeys and travels all over the world still leave you gloomy and with a heaviness in your mind?

animum debes mutare, non caelum.
You need to alter your mind, not the sky above you.

Because your faults will follow you wherever you go and

tecum fugis.
You run away with yourself.

Because of this, he says, all the wonders of new lands can be of no use to you. In fact, the wandering makes the problem worse. It is a bit like the cargo on a ship, says Seneca: at least when the ship is at rest, the cargo is stable, but once the ship starts to move from side to side, the cargo makes the ship heel in the direction it has settled on. The problems you are trying to deal with are what you have to begin with, and only then can you benefit from exploring the world.

Seneca makes clear that the person you are matters more than where you go. If you don't know who you are and what you want, you are not travelling at all, you are merely

drifting, hoping that the answer will find you, rather than finding the answer yourself.

Stoicism puts a great deal of emphasis on the individual sorting out their own problems, and you need to use reason (*ratio*) to do this; this is why Lucillius has to sort out his head first. The problem with a life ruled by reason is that there is no room for emotion. Emotions, for the Stoics, were reasons you had not yet got to grips with.

But that doesn't cover it all. What happens when someone comes up behind you and shouts 'BOO!'? You jump. That is not an emotion, because you cannot begin to rationalise or control it. It is a reaction. For the Stoics, it is one of the *hormai*. It is the word that gives us 'hormones': they are raw and often uncontrollable by the rational mind, but they still make us do stuff. The word in Greek means something like 'urge'. It is the final move in the Stoic game. They realise that there are aspects of the human condition we cannot control completely.

At the other end of the spectrum, at the top of the Stoic tree is the wise man (*sapiens*). As Seneca puts it, he will endure a choppy sea, but he will not go looking for it. He can take all troubles in his stride because his reason allows him to understand the true, and usually trivial, level of the problem. He is what everyone wants to be: someone who is not fazed by anything because reason dictates his life.

The idea of the Stoic wise man, or sage, might be one reason why we have so much of Seneca's work: the Christian church thought highly of him, and so manuscripts of his work were well-preserved. He is a subtle writer, but

accessible, and his sage in many ways is a Christ-like figure, since the sage is someone we are meant to aim to be. Some medieval works, such as the Golden Legend, even claim that St Paul baptised Seneca as a Christian. His death, by cutting his veins in the bath, was even viewed as kind of baptism.

Seneca was also a literary man and he quotes some of the big guns, such as the poet Virgil and the philosopher Socrates – if they make similar claims to Seneca, how could he possibly be wrong? He even quotes a philosophical rival, Epicurus:

initium est salutis notitia pecatti.

The knowledge of what you've done wrong is the beginning of salvation.

You can see why the church liked him: *peccatus* is the Latin word the church used for 'sin'.

Lucillius, Seneca's nephew, is told to be his own prosecutor, judge and finally intercessor: he must find out all the charges against himself, prove himself guilty and even be harsh with himself. That is the way to get the healthy mind that will mean he is not just dragging his problems around with him.

Seneca was one of the gentlest philosophers. He had, it seems, a poor room, one in which he learned to live without the massive trappings of wealth that being favoured by the emperors gave him. He also had a sense of humour. He wrote about the 'Pumpkinification' of the Emperor Claudius, a wordplay on his 'deification'.

Seneca gets good press in Chaucer, Dante and Montaigne. Erasmus produced an edition of his work, and he was one of the few writers given a reasonable time by John Calvin in a commentary. His work has influenced many great writers, including Corneille and Racine.

A much earlier Stoic, Hierocles (2nd century BC), known only through fragments, also looked at ethics and how we can sort out relations between ourselves. He devised a notion of concentric circles. At the middle, we find ourselves. Then, at the next level, we find our immediate family, then friends, then a district, then a city and so on until we reach the whole world.

The point is the same as Seneca's message. We absolutely have to begin with ourselves. Once we know ourselves – really understand who we are and what we want – we can move on to have real relationships with our immediate family, then our friends, neighbours and so on. Until, in a genuinely hippie way, we love the world.

stóick. n.s. [Greek *stoikos; stoique*, Fr.]
A philosopher who followed the sect of Zeno; holding the neutrality of external things.

> *While we admire*
> *This virtue, and this moral discipline,*
> *Let's be no stoicks, nor no stocks, I pray.*

Shakespeare
[*The Taming of the Shrew*, Act 1, Scene 1]

Samuel Johnson's *A Dictionary of the English Language* (1755)

All Cretans are liars

Epimenides, a man from Crete, is claimed to have said, around 600 BC: 'All Cretans are liars.'

Now, what are we to do with this? Is what he says true or false – or can we not tell?

One way of looking at the problem is that we cannot tell, because we can either say that Epimenides says something *true* or something *false*, but each route leads us to a contradiction.

Firstly, we can consider that the statement 'All Cretans are liars' is false. If it's false – if it is *not* the case that all Cretans are liars – then it must be true that Cretans are liars, because Epimenides, a Cretan, told us something that is not true. So we have stage one of a paradox.

If it is true that Cretans are liars, then Epimenides told us something that is false, because he told us something true (Cretans lie) when he meant to be a liar and tell us something false. So, we have stage two of the paradox.

In fact, we don't have a paradox at all. If you look on the internet, you can find all kinds of nonsense about the liar paradox, as it is called. All you really need is a bit of logic.

Let's consider all the books in the library. If I say, 'All the books in the library are green', have I said something true or false? Clearly (unless there is an amazing publishing accident) I've said something false. It is not the case that all the books in the library are green – they are all kinds of colours. But some of them could still be green. What

about all the women in the world? 'Not all the women in the world are blonde.' Does that mean that *no* women in the world are blonde? Aren't we actually saying something like this: 'It is not the case that all the women in the word are blonde, but some of them are'?

A *big* logical mistake that people can make is to assume that when you want to say 'not all' you mean 'none'. That is, when you want to say, 'Not all the books in the library are green' this is taken to mean, 'none of the books in the library are green'. In fact, if you say logically 'not-all', you end up with 'some'. The point is that if you say not-all books in the library are green, you are left with the line that some are. If you say not-all women in the world are blonde, that does not mean that there are no blonde women. There are some.

So, how do we find out about Cretan liars? Are there some or none?

The contradictory paradox arose because of the assumption that the way of saying 'not-all' was 'none'.

Let's try again. If it is true that all Cretans are liars, then we are back where we began, because Epimenides has said something true, and he is meant to be a liar.

The crucial point comes when we consider that what he says is false. In this case, he is saying that it is not the case that all Cretans are liars. Not all books in the library are green. Not all women are blonde. Some are. The *opposite* of 'all' is 'none'. That is not what we want. The *negation* of 'all' is 'some'. Some women are blonde. Some books are green. Some Cretans are liars. When what Epimenides

says is false, then he says something meaningful. Whether Epimenides himself was a liar is lost to history, but to say something false is not always to say nothing, or just to lie – sometimes it is the way out of a paradox. By looking at the logical possibilities, Epimenides said something worth saying, but in a way you had to work out. That is interesting language.

lógick. n.s. [*logique*, French; *logica*, Latin, from Greek *logos*]
The art of reasoning.

> *Logick is the art of using reason well in our inquiries after truth, and the communication of it to others.*
>
> Watt's Logick.

> *Talk logick with acquaintance,*
> *And practise rhetoric in your common talk.*
>
> Shakespeare.
> [*The Taming of the Shrew*, Act 1, Scene 1]

Samuel Johnson's *A Dictionary of the English Language* (1755)

NOW FOR A SHORT WRITTEN TEST ...

◆ When were the Olympic Games first held?
◆ If you competed in the ancient Olympics, what did you wear?
◆ Why is a marathon so called and why is it 42.195 kilometres (26 miles and 385 yards) long?

SEX, DRUGS AND ROCK AND ROLL

At last, we reach what everyone really cares about. Here we find minimal changes between how the ancient Greeks and Romans approached sex, drugs and all the rest, and how we approach them now. Two-thousand years on, we're still just as messed about or as loved as we ever were, and we still can't seem to manage relationships any better.

What is love?

A *symposium* was a Greek men's dinner party. Its two chief components were getting incredibly drunk and then retiring with the flute girls who had provided musical entertainment earlier in the evening.

Plato wrote a dramatic dialogue called the *Symposium*, which is a philosophical discussion of the nature of Love. The dialogue involves a series of historical characters who were said to have drunk too much the night before and decided they didn't fancy the flute girls that night, but wanted to discuss the nature of Love itself instead.

At one level, it is a complicated mechanism through which Plato, via his mentor Socrates, can dismiss other notions of love and claim that the true lover is a *philosopher* (as the literal meaning of the term is a *lover of wisdom*).

In the dialogue, Pausanias discusses the customs of Athens: some are base and only focused on sex and lust, while others are noble and look for a long-lasting and intellectual connection. Eryximachus is a doctor and so gives a medical description of love: where there is repletion or depletion in the body, the doctor can use love to bring back harmony in the body. We hear a speech from the tragic poet Agathon in the form of the rhetoric that was all persuasion and had little analysis of the truth – and that was despised by Socrates.

At the end of the dialogue, the young and drunken politician, Alcibiades, stumbles in. He was notorious for his handsomeness, just as Socrates was known for his ugliness. Alcibiades says that he thought Socrates was pursuing him as a lover, and he was willing to give in to him so that he could learn all of Socrates' wisdom. But Socrates did not make a move on him at all. Finally, Alcibiades began pursuing him, when it was customary for the older man to pursue the younger. He even did the equivalent of getting into bed with him, by getting under his cloak as he slept. Socrates made no advances at all to Alcibiades, so Alcibiades talks about how he ended up falling in love with Socrates, when he believed at the beginning that it was the other way round. Alcibiades points out that this is a danger to be wary of.

I have deliberately taken one speaker out of turn. In my opinion, this is the best story there is about love. As with a poem of Sappho (p. 203), it describes what it is to be in love.

The comic poet Aristophanes describes love as a fiction made up in the dialogue by the comic poet Aristophanes in the form of a myth about the origins of human nature.

He says that humans were different once. There was not just male and female, as now, but three kinds of human beings: male, female and a combination of the two, the 'androgynous'. Every human being was completely round, in the shape of a sphere, with four hands and four legs and two faces on opposite sides of one head with four ears. Each human had two sets of sexual organs. They walked upright, as humans do now. When they wanted to run fast, they stuck out all their eight limbs straight and spun over and over, like gymnasts doing cartwheels.

The male was the offspring of the sun, the female of the earth and the androgynous of the moon, so they looked like their planet parents.

The spherical humans were incredibly strong and powerful and they made an attack on the gods. So, Zeus, the king of the gods, together with the other gods, considered what to do to make them weaker: they did not want to kill them all because they wanted to continue to get offerings from them. Then Zeus decided to cut each human in two so that they would walk upright on two legs, rather than four. If they continued to be a nuisance, Zeus said he would cut them in half again, so they would have to get around by hopping on one leg.

Each human was cut in two, and Zeus told the god Apollo to turn each head towards the wound as a reminder of what had happened. Apollo smoothed out the wrinkles of the wound, apart from gathering the skin at the navel, as another reminder.

As they had been cut in two, each half longed for the

other. They threw their arms around each other and wove themselves together as they wanted to grow back into being one again. In this state, they died of hunger, as all they did was cling to each other.

Finally, Zeus took pity on the wretched humans. He moved their genitals from the back to the front, so they could have sex together. Through this, they got some relief and so could go back to the rest of their lives. This, claims Aristophanes, is the origin of our desire to love one another:

> As a result, love for one another is innate within humans, reminiscent of our ancient nature, in an attempt to make one out of two, and heal the way of being of human kind (191d).

Each of us is, therefore, a broken half of a dice, a flat fish sliced in two. We are all, forever, looking for the other half of our dice, the other half of our sphere.

If you were part of a woman-woman sphere, you seek the other woman; if you were part of a man-man sphere, you seek the other man; the partners of the androgynous sphere are a man and a woman.

As a result, mere sex is not why people are together. Some people spend their whole lives together and cannot explain why. If Hephaestus, the blacksmith, the builder god, saw these two together, no such couple would stop him from fusing them together as one so that they would never be separated by day or by night and so could become one being.

They would then be one in the land of the dead, in Hades, as, again, they had lived one life.

Love is our way of seeking wholeness, of trying to be complete.

Two poets

Sappho, from a 19th century illustration by Léon Bazille Perrault

Sappho encapsulates a mystery. We know – as far as we know anything – that she was a woman who lived at least some of her life on the Greek island of Lesbos in the 600s BC.

The 19th century gave us the words *lesbian* and *Sapphic* because of the kind of love she might have described. Whether she is talking about men, women or both, it is the passionate love that she writes about so intensely in her poetry that gave her a reputation in antiquity that survives today, even though most of her works are lost.

She wrote about the human condition in all its extreme forms, as far as we can tell from the fragments that survive. She wrote about old age, about longing, about the erotic.

Fragment 1 of her poems ends this way:

Come to me even now, and release me
from dreadful solitude.
All that my heart desires to fulfil: fulfil.
You need to become my battle companion.

Her most famous poem is fragment 31.

He seems to me to be the equal of the gods,
the man who sits opposite you
and, up close, hears you sweetly
singing.

and your desirous laugh. That has made the heart in
my chest
beat in furious despair.
For when I look at you for even a second,
I no longer have the ability to speak.

My tongue is torpid. A subtle, immediate
flame runs under my skin.
My eyes are blind of colour,
My ears ring.

A freezing sweat takes hold of me,
A trembling grabs me all over,
I am paler than grass,
I am a short step from death.

But all must be dared because …

Perhaps the fact that we don't know how it ends, because
the rest of the poem is lost, adds to its charm in the
same way that we like pure, white ancient statues when,
in fact, we know that they were often painted in garish
colours.

Psudo-Longinus, who quotes this poem for us in
de sublimitate, On the Sublime, and is otherwise unknown,
makes clear the brilliance of Sappho's art:

Is it not wonderful how she summons at the same
time soul, body, hearing, tongue, sight, colour, all as
though they had wandered off apart from herself?
She feels contradictory sensations, freezes and burns,
thinks unreasonably … She wants to display not a
single emotion, but a whole congress of emotions.
Lovers all shew such symptoms as these, but what

gives supreme merit to her art is, as I said, the skill with which she chooses the most striking and combines them into a single whole

<div align="right">Trans. Hamilton Fyfe</div>

The best line in the poem describes her feelings when she sees her lover entranced by another. She is 'paler than grass'. This is not the green, green grass of the Welsh valleys. She is not green with love sickness or jealousy. The grass is pale. The grass is white. This is the burnt, shrivelled grass that has endured the searing heat of a Greek summer on a hillside and been turned to an albino husk. It is dead grass.

That is how to write about passion.

In the strange, modern world of copyright and plagiarism, it is interesting to reflect on the fact that taking another's work and re-working it to make it your own, while the original could be discerned, was a form of literary flattery. But that is exactly what the Roman, Latin-speaking, Catullus (c. 84–54 BC) did when he used Sappho's Greek poem to make a point of his own. This (poem 51) is possibly his most famous poem too.

> He seems to me to be the equal of a god,
> He, if it is right, is superior to the gods,
> Who, sitting opposite you,
> watches you and

Hears you sweetly laughing. I am wretched
because this snatches all my senses away.
For as soon as I see you, Lesbia, there is no
 voice in my mouth

My tongue is torpid,
a subtle flame runs down my limbs.
My ears ring with their own sound,
 my eyes are covered by a two-fold night.

So far, so, perhaps, predictable, after Sappho. (N.b. his pro-
posed girlfriend is called Lesbia after Sappho's Lesbos.) But
the Romans were about money, business and conquests.
There was, ultimately, no nonsense. So, Catullus' last verse
in his poem breaks with Sappho and puts him back in
the world of politics, the forum and business, where he
belonged:

Idleness, Catullus, that is your problem.
You enjoy and relish your idleness too much.
Idleness, before now, has destroyed
 kings and beautiful cities.

Basically, get up. Get out and back to work. That is the
Roman way. Because sitting there thinking about anyone
will get you nowhere on its own. It is also a political point
he makes: idleness has brought down rulers and cities: the
stuff, in the end, that Romans really did care about.

Catullus' sparrow

The Roman poet Catullus (c. 84–54 BC) wrote about his affair with a woman called Lesbia (see p. 206). People have tried to reconstruct the course of the affair from the first flush of love to the bitter end, and to pin down exactly who Lesbia was. But it is not clear that there ever was such an affair. That doesn't mean that Catullus didn't understand about love or the anguish of the end of an affair, rather that he could have used the experience to create a literary artifice. But there is much more to him than that.

This is one of Catullus' love poems. I first read this one at school for an exam. It seems at first to be a rather sweet conceit on the pet sparrow Lesbia appears to have kept, and it uses the poetic metre of a hymn:

Passer, deliciae meae puellae,
quicum ludere, quem in sinu tenere,
cui primum digitum dare appetenti
et acris solet incitare morsus,
cum desiderio meo nitenti
carum nescio quid libet iocari
et solaciolum sui doloris,
credo ut tum gravis acquiescat ardor:
tecum ludere sicut ipsa possem
et tristis animi levare curas!

Sparrow, my girl's pet,
with which she often plays while
 she holds you in her lap,
to which she is accustomed to
 give her fingertip to peck
and provoke to bite sharply,
when my shining desire
wants to play around with
 something dear
and find some relief from her pain,
I believe that then there is some
 relief from the weight of love:
I wish I could play with you just
 as she does
and lighten the sad cares of my
 soul!

It is clearly a poem of delight, perhaps even triumph. At school, we all had rather a shock when we realised that *passer*, the sparrow, can also be a euphemism for the penis. If you read it again now, you can see that Catullus is playing a double game here, and the second reading is far raunchier …

We hear more about the sparrow. There is another poem, this time in the metre of a dirge, a funeral song. The sparrow is dead.

Lugete, o Veneres Cupidinesque,
et quantum est hominum venustiorum:
passer mortuus est meae puellae,
passer, deliciae meae puellae,
quem plus illa oculis suis amabat.
nam mellitus erat suamque norat
ipsam tam bene quam puella matrem,
nec sese a gremio illius movebat,
sed circumsiliens modo huc modo illuc
ad solam dominam usque pipiabat.
qui nunc it per iter tenebricosum
illuc, unde negant redire quemquam.
at vobis male sit, malae tenebrae
Orci, quae omnia bella devoratis:
tam bellum mihi passerem abstulistis
o factum male! o miselle passer!
tua nunc opera meae puellae
flendo turgiduli rubent ocelli.

Grieve, o Loves and Desires,
and all men of rather good taste.
My girl's sparrow is dead,
the sparrow, my girl's pet,
that she loved more than her own eyes:
for it was her honey
and it knew his mistress
as well as a little girl knows her mother;
Nor would it move from her lap,
but hopping now here, now there,
used to chirp continuously for its mistress alone.
Now it goes on a dark journey,
to that place from where they say that no one returns.
But damn you, cruel shades of Orcus [the underworld]
which devour all pretty things:
you have stolen away such a lovely sparrow from me.
O terrible deed! O wretched little sparrow!
Now, because of your doing, the little eyes of my girl
are rather swollen and red with weeping.

The language is highly erotic again and it can come as no surprise that some have taken this poem to have a double meaning too, perhaps that of sexual impotence. Lesbia is not happy that the sparrow is gone.

But there is another interesting point about Catullus' language. Some of it is very simple. It is the language that you might have heard in the street: *passer mortuus est meae puellae*, 'the sparrow of my girl is dead'. It is the kind of Latin (without the smut) that you would have come across if you were just starting to write Latin as a school exercise. What Catullus has done is turn basic, ordinary Latin into high poetry through his tricks with meanings and metre, and his use of the unexpected. In other poems he uses vocabulary and references designed to be picked up by only the most accomplished literary critics. Those poems are show-off pieces for writer and reader alike (hey, I got that point!). But I don't think they are as effective as poems such as these. These ones really grab you. I think this is one reason why people still look to work out his 'affair': they are so fresh and alive that surely he *must* be talking about something real. They don't *feel* 2,000 years old.

It is that modernity that makes Catullus, somehow, enduringly new. He writes about dinner parties and he attacks the politicians of his day. He makes fun of people. He talks about his friends and their quarrels, he makes up the word 'kissifications' (*basiationes*) in a poem about how many times he wants to kiss his mistress (an infinite number, in fact). He writes incredibly movingly about the funeral of his brother. He could also show bitter hatred:

Nulli se dicit mulier mea nubere malle
quam mihi, non si se Iuppiter ipse petat.
dicit: sed mulier cupido quod dicit amanti
in vento et rapida scribere oportet aqua.

My woman says that she wanted to marry no one other than me,
not even if Jupiter [king of the gods] himself should pursue her.
That is what she says: but what a woman says to an eager lover
should be written on the wind and rapid water.

Catullus speaks like us because he was like us. He is very strikingly someone through whom we can see ourselves in the past.

Catullus' two-liner

Odi et amo. Quare id faciam, fortasse, requires?
Nescio, sed fieri sentio et excrucior

I hate and I love: you might ask, perhaps, how this can happen?
I don't know, but I certainly feel it, and I am in torment.

The only two-line poem in this league is by Wendy Cope and also deals with the end of an affair:

Two cures for love

1. Don't see him. Don't phone or write a letter.
2. The easy way: get to know him better.

Ancient methods of contraception

The year 2010 marked the 50th anniversary of the contraceptive pill. The pill sparked the sexual revolution and enabled women to have much more control over their bodies and their lives.

Ancient women cared about just the same things. They had to find their own ways to avoid unwanted pregnancies. There are all the obvious things to do, that we know don't work very well. But there is also a story of pharmacology here: there were some pretty powerful drugs that could be extracted from plants. While there are claims that some of them have been tested in the Far East, try them at your peril.

It seems there might have been a miracle drug. It was called silphium and grew in North Africa. The poet Catullus (pp. 208 and 211) talks of the 'silphium-bearing shores of Cyrene' because the plant was so important there. It was even pictured on their coins. It was so useful that it was harvested to extinction and we now cannot know what it could do. It was used for everything: perfume was made from its flowers, the stalk was edible, and the medicine came from its resin and roots. It seems to have been used as a contraceptive from the 7th century BC and was very much prized by the Egyptians. Pliny the Elder said the resin could be used as a pessary when put on wool in order to prevent a pregnancy.

Another drug used was the wild carrot, or Queen Anne's Lace (*Daucus carota*), which seems to have looked a

bit like silphium. Hippocrates (pp. 79, 85) described its use as a contraceptive and abortifacient (it is difficult to separate contraceptives and abortions, especially early ones, in the ancient world for obvious reasons). It is said to be incredibly powerful, especially the seeds. It was used especially as a kind of 'morning after' pill.

Pennyroyal is a plant related to the herb mint, and smells like it too. The Greeks and Romans used it to cook with, to flavour wine and to make a herbal tea. The 1st century doctor Dioscorides recorded its use to bring on menstruation and abortions. However, if you took too much, it could bring on organ failure.

Soranus is interesting: he wrote an entire book on gynaecology in the 2nd century BC in Greece. He talks about the plant 'rue'. It is a herb that is actually quite pretty: it is bluey-grey, and gardeners grow it because it is pretty difficult to kill off. You can use it in very small amounts in cooking, but it is a very potent abortifacient as it reduces blood flow to the lining of the womb.

So, women took their health in their hands when they used these drugs. At least they didn't do what ancient Chinese women did to prevent pregnancy: drink a nice cup of hot mercury ...

The old six-string

The ancient world is a silent place for us now. We can put on a play to bring back some voices from the past,

based on assumptions about how Latin and Greek were pronounced. But it is a basically a world where its literature is read in quiet libraries and its art and architecture admired in hushed awe. In fact, the ancient world was pretty loud. Not only would there have been the shouting and yelling of the markets and everyday life, but it seems there was music everywhere.

There would be music from flute girls at parties. Music accompanied all kinds of religious festivals and rites and funerals, even sacrifices. There were music competitions and music in theatrical productions. The philosopher Plato even discussed 'the music of the spheres' as a way of indicating – literally – the harmony of the universe. The mathematics of the universe worked like the maths that underlies music. And the universe even sounded good. Literature by Homer and Sappho was recited to music: literature began as songs.

At the centre of it all is the lyre. Its ubiquity made it the guitar of its day, and it graduated into harps and lutes. It had a varying number of strings: four, seven and ten were the most popular. To learn to play the lyre was part of a sophisticated education. The god Hermes is said to have invented it from a tortoise shell, gut and reeds in order to steal away the sacred cattle of the god Apollo.

Lyres generally had two upright arms or horns that were fixed and a crossbar with tuning pegs. They could be made of bone, wood or metal. The strings were made of gut and plucked with a plectrum.

The lyre is everywhere in art: on vase paintings, on sarcophagi, in sculpture. It is found depicted on coins.

Two other instruments central to the musical repertoire were the kithara and the aulos. The kithara was like a very big lyre and was played standing up, also with a plectrum. The aulos, seen widely in art, was rather like a double flute or an oboe, and comprised of a set of double pipes with reeds as mouthpieces; these were held out in front of the player.

Perhaps it is possible to get some idea of how it all sounded from the rhythm and stresses found in the metres of poetry. We have fragments of scores showing a basic musical notation, but this is not the library of music we would like. Music was also clearly danced to, but we know very little about ancient dancing either. We have the names of ancient dances, but what would we make of the 'waltz' if the name were all we had? We can reconstruct ancient instruments from the evidence we have. But this one is lost to us; we will never know what it really sounded like.

NOW FOR A SHORT WRITTEN TEST ...

* The Emperor Caligula loved his horse Incitatus so much, what did he try to do?
* What is the Emperor Nero said to have done while Rome burnt down?
* Which clothes did the Emperor Caligula like to wear in private and public?

NOW FOR SOME ANSWERS ...

Page 42
- Only the senators or the emperor. It was made by squeezing the dye out of a small shellfish called a *murex*.
- Claudius. His third wife, Messalina, is said to have beaten a prostitute in a competition to see how many men they could sleep with in one night.
- Human urine, collected from communal urinals, as it contains the ammonia needed to bleach clothes.

Page 73
- If you were an ancient Greek listening to someone speaking a foreign language, all you could hear was 'bar ... bar ... bar ...'
- Only men or boys; they took the female roles too.
- In ancient Greece, the sacrifice of 100 cattle for religious purposes.

Page 89
- A cure for epilepsy. Drinking blood for therapeutic effect continued into modern times. Hans Christian Andersen reported in 1823 that he saw someone drink the blood of an executed person in the hope of a cure.
- An erect penis. And yes, people did wear models of them as necklaces and hang them from doorways.
- Empedocles thought that they contained reincarnated souls (who presumably had not done well in their last life – but still, you didn't want to eat Granny, did you?).

Page 118

+ Captured Christians who were set on fire.
+ Hoplites were trained foot soldiers. They used swords, spears and the round shield (*hoplon*) that gave them their name.
+ It was a Greek warship, rather like a galley ship, with three rows of oars. It was rowed by free men as an important part of military service.

Page 154

+ From the first two letters of the Greek alphabet: *alpha* and *beta*.
+ Socialise.
+ Julius Caesar says this when he is stabbed in the back by his supposed best friend Brutus. In fact, there is no evidence that the real Caesar said this at the time of his death, but his character does in *Julius Caesar*, the play by William Shakespeare (3.1.77).

Page 198

+ 776 BC.
+ Absolutely nothing.
+ That is the distance that Pheidippides ran from Athens to Sparta. He was asking the Spartans for help against the Persians in what would be the Battle of Marathon (490 BC).

Page 215

+ Get him made a consul (the highest job in government).
+ He 'fiddled while Rome burned': the historian Suetonius says he played the lyre.
+ Women's clothes.

ACKNOWLEDGEMENTS

There is a way in which this book is dedicated to everyone who ever taught me. Because they moulded me. But, my friends and I tortured them at school, I fear.

There was the completely lovely History teacher throughout whose class we hummed and blamed it on the radiator. We told an RE teacher (who was married to a bishop) that we had contacted the devil by reading the Lord's Prayer backwards (we were told we were going to hell), and we spent an entire lesson looking for a contact lens that Debbie didn't wear. Then there was the time a Classics teacher's slip fell to the floor... And we all had a crush on our head Latin teacher.

Then there were the tutors I met at university: some dozed in the sunshine and some taught me to think. If anyone at all has ever shaped the way my little brain works, it is my former supervisor, Prof David Charles, now of Yale.

I would never have written this book had it not been for an incredibly funny and incredibly clever former student of mine: Harry Scoble-Rees. Thank you for thinking I could pull this off. Yours was the best year I have ever taught.

I desperately need to thank everyone at Icon Books for all their help. When I rocked up to this project, I could write academically, but the gentle and wise advice of Duncan Heath meant that I was steered to write in the way I had always, really, wanted to.

Then there was Kiera Jamison, who knocked the rough corners off the text in the way that the Epicureans discussed how a square tower, at a distance, can appear round. (It is because the corners of the square atoms are knocked off through the distance they have to travel to your eye, so they look round.) I also would like to thank Andrew Furlow and Henry Lord for doing all the clever things to do with business that my father told me to avoid, as he said I would have been sacked within a fortnight.

My neighbour, Tom Fasham, a distinguished structural engineer, read my piece on concrete and arches to make sure that I had not made a complete fool of myself as I strayed into slightly alien territory. Thank you so much for all your comments and thinking it was OK.

My lovely colleague, Dr Regine May, of the University of Leeds, did me the ultimate kindness in reading the whole thing and telling me where I had over-stepped the mark. You are a true scholar, definitely a gentlewoman and a wonderful friend.

I also want to thank Emma Howes. We have known each other a horrific number of years, but we can always keep each other on the straight and narrow. Thank you for being such an amazing friend and support.

In the end, I have to thank my three small children, Bryn, Carys and Elen, for finally going to sleep so that this book could become a reality.

FURTHER READING

In case you want to find out a little more ...

What it was like ...

Hornblower, S., A. Spawforth & E. Eidenow (2012) *The Oxford Classical Dictionary*. Oxford: Oxford University Press.

Shelton, J. A. (1988) *As the Romans Did: a Sourcebook in Roman History*. Oxford: Oxford University Press.

Edwards, J. (1985) *The Roman Cookery of Apicius*. Rider & Co.

Wood, M. (1997) *In the Footsteps of Alexander the Great*. London: BBC Books.

The Antikythera Mechanism Research Project. http://www.antikythera-mechanism.gr/project/overview.

de Solla Price, D. (1974) 'Gears from the Greeks. The Antikythera Mechanism: A Calendar Computer from c. 80 BC'. *Transactions of the American Philosophical Society*, new series, 64. No. 7. pp. 1–70.

Icks, M. (2013) *The Crimes of Elagabalus: The Life and Legacy of Rome's Decadent Boy Emperor*. London: I.B. Tauris & Co. Ltd.

Art and literature: a smorgasbord

Euclid, D. Densmore & T.L. Heath (edd.) (2002) *Euclid's Elements*. Santa Fe: Green Lion Press.

Autenrieth, R. (2013) *Homeric Dictionary*. London: Bloomsbury.

Jenkins, I. & I. Kerslake (2007) *The Parthenon Sculptures in the British Museum.* London: British Museum Press.

Aeschylus, *Prometheus Bound and Other Plays.* London: Longman.

Aristophanes & Sommerstein (trans.) (1973) *Lysistrata, The Archanians, The Clouds.* London: Penguin.

Petronius & P.G. Walsh (trans.) (2009) *The Satyricon.* Oxford: Oxford University Press.

Boardman, J. (2006) *The World of Ancient Art.* London: Thames and Hudson.

Magic and medicine: is any of it rational?

Graf, F. (1999) *Magic in the Ancient World.* Cambridge: Harvard University Press.

Ogden, D. (2002) *Magic, Witchcraft, and Ghosts in the Greek and Roman Worlds.* Oxford: Oxford University Press.

King, H. (1998) *Hippocrates' Woman: Reading the Female Body in Ancient Greece.* London: Routledge.

Jouanna, J. & M.B. DeBevoise (trans.) (2001) *Hippocrates.* Baltimore: The Johns Hopkins University Press.

When things go wrong, or at least get tricky …

The Holy Bible: King James Version, 2011 edition. Harper Collins.

Sophocles & P. Easterling (ed.) (2003) *Antigone.* Cambridge: Cambridge University Press.

Barnes, J. (2002) *Early Greek Philosophy.* London: Penguin.

Tacitus & M. Grant (ed.) (2003) *The Annales of Imperial Rome.* London: Penguin.

Farmer, D. (2011) *The Oxford Dictionary of Saints.* Oxford: Oxford University Press.

Modern scholars, ancient languages

Luttwak, E.N. (1996) *The Grand Strategy of the Roman Empire*. Baltimore: The Johns Hopkins University Press.

Hammond, N.G.L. (1983) *Venture into Greece: With the Guerillas, 1943-44*. William Kimber & Co Ltd.

Liddell, H. & R. Scott (edd.) (2007) *Liddell and Scott's Greek-English Lexicon, Abridged*. Oxford: Oxford University Press.

Parkinson, R. & S. Quirke (1995) *Papyrus*. London: The British Museum Press.

Bowman, A.K. (1994) *Life and Letters on the Roman Frontier*. London: The British Museum Press.

Bowman, A. & D. Thomas (1994) *The Vindolanda Writing Tablets (Tabulae Vindolandenses II)*. London: British Museum Press.

Casson, L. (2001) *Libraries in the Ancient World*. Yale University Press.

Parkinson, R. (2005) *The Rosetta Stone*. London: The British Museum Press.

Heaps, triangles and other philosophical quandaries

Kirk, G. S., J.E. Raven & M. Schofield (1984) *The Presocratic Philosophers: A Critical History with a Selection of Texts*. Cambridge: Cambridge University Press.

Lucretius & R. Jenkyns & A. Stallings (edd.) (2007) *The Nature of Things*. London: Penguin.

Plato & J.M. Cooper & D.S. Hutchinson (edd.) (1997) *Complete Works*. Indianapolis: Hackett Publishing Company, Inc.

Aristotle & L. Brown & D. Ross (edd.) (2007) *The Nicomachean Ethics*. London: Penguin.

Seneca & R. Campbell (ed.) (2004) *Letters from a Stoic.*
London: Penguin

Sex, drugs and rock and roll
Barnard, M. (2012) *Sappho.* Berkeley & Los Angeles:
University of California Press.
Catullus & G. Lee (ed.) (2008) *The Poems of Catullus.* Oxford:
Oxford University Press.
Fantham, E., H. Peet Foley, N. Boymel Kampen &
S.B. Pomeroy (1995) *Women in the Classical World.* Oxford:
Oxford University Press.
Landels, J.G. (1999) *Music in the Ancient World.* London:
Routledge.

ALSO AVAILABLE

The Collector's Cabinet

Explore the wonderful world of antiques and
collectables with BBC *Antiques Roadshow*
regular, Marc Allum.

Go in search of stolen masterpieces, learn the secrets
of the forgers, track down Napoleon's toothbrush
and meet the garden gnome insured for £1 million.

Eclectic, eccentric and brimming with remarkable
tales from history, *The Collector's Cabinet* is for all
those who are fascinated by the relics of the past.

ISBN: 9781848319110 (paperback)/
9781848319127 (ebook)

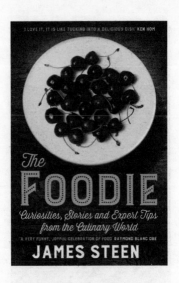

'I LOVE IT, IT IS LIKE TUCKING INTO A DELICIOUS DISH' KEN HOM

The
FOODIE
Curiosities, Stories and Expert Tips
from the Culinary World

'A VERY FUNNY, JOYFUL CELEBRATION OF FOOD' RAYMOND BLANC OBE

JAMES STEEN

The Foodie

Join award-winning food writer James Steen for a feast of facts, stories, recipes and tips about food and drink.

Delving into forgotten corners of gastronomic history, Steen reveals what Parmesan has to do with broken bones, why John Wayne kept a cow in a hotel and how our attitudes to horsemeat have changed. Laying bare the secrets of the kitchen, he concocts the ultimate hangover cure and explains how to cook perfect rib of beef with the oven off.

With much-loved cooks including Mary Berry and Michel Roux Jr sharing their passion and know-how, this mouth-watering miscellany will sate the appetite of every kitchen dweller, from the masterful expert to the earnest apprentice.

ISBN: 9781848319882 (paperback)/
9781848319875 (ebook)

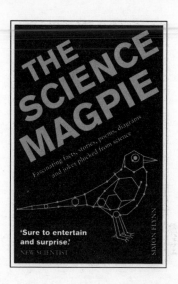

The Science Magpie

From the Large Hadron Collider rap to the sins of Isaac Newton, *The Science Magpie* is a compelling collection of scientific curiosities.

Expand your knowledge as you view the history of the Earth on the face of a clock, tremble at the power of the Richter scale and learn how to measure the speed of light in your kitchen.

Skip through time with Darwin's note on the pros and cons of marriage, take part in an 1858 Cambridge exam, meet the African schoolboy with a scientific puzzle named after him and much more.

ISBN: 9781848315990 (paperback)/
9781848314313 (ebook)

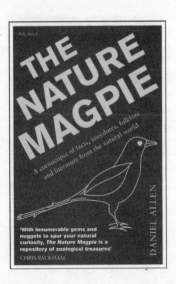

The Nature Magpie

A collection of anecdotes, facts, figures, folklore and literature, *The Nature Magpie* is a veritable treasure trove of humanity's thoughts and feelings about nature.

With acclaimed nature writer Daniel Allen as your guide, join naturalists, novelists and poets as they explore the most isolated parts of the planet, choose your side – pineapple or durian – in the great 'king of fruits' debate and discover which plants can be used to predict the weather.

Meet the roadkill connoisseurs, learn to dance the Hippopotamus Polka, find out the likelihood of sharing your name with a hurricane – and much more.

ISBN: 9781848316584 (paperback)/
9781848315341 (ebook)